MW00633629

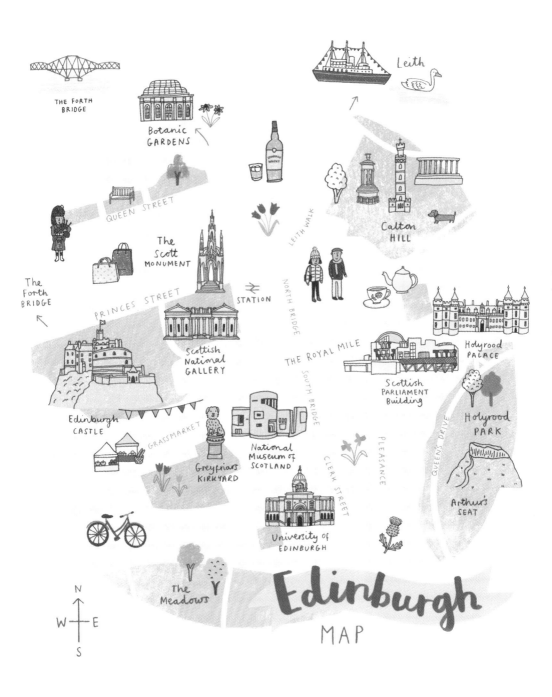

THE FORTH BRIDGE

Botanic GARDENS

EDINBURGH WHISKY

Leith

QUEEN STREET

The Scott MONUMENT

LEITH WALK

Calton HILL

The Forth BRIDGE

PRINCES STREET

STATION

NORTH BRIDGE

Scottish National GALLERY

THE ROYAL MILE

SOUTH BRIDGE

Holyrood PALACE

Edinburgh CASTLE

GRASSMARKET

Greyfriars KIRKYARD

National Museum of SCOTLAND

CLERK STREET

PLEASANCE

QUEENS DRIVE

Scottish PARLIAMENT Building

Holyrood PARK

Arthur's SEAT

University of EDINBURGH

The Meadows

Edinburgh
MAP

N
W E
S

THE
EDINBURGH
ART BOOK

Published by UIT Cambridge Ltd

www.uit.co.uk

PO Box 145, Cambridge CB4 1GQ, England

Phone: +44 (0) 1223 302 041

First published in 2019, in England.

Reprinted in 2020.

ISBN: 978-1-906860-92-9 (hardback)

ISBN: 978-1-906860-93-6 (ePub)

ISBN: 978-1-906860-94-3 (pdf)

Also available for Kindle.

3 5 7 9 10 8 6 4 2

THE
EDINBURGH
ART BOOK

THE CITY THROUGH THE EYES OF ITS ARTISTS

EDITED BY

EMMA BENNETT

UIT
CAMBRIDGE

Acknowledgements

The Edinburgh Art Book has been made possible by the enthusiasm of the contributing artists and to them I am eternally grateful, you are an inspirational bunch.

To the background sound of bagpipes, an illustrious panel of local art and city experts helped select the images for publication and I am indebted to them for their creative input. They are:

- Peter Bourhill (*Editor: Edinburgh Life Magazine*)

- Helen Brown (*Director: ArtSquat*)

- Jonathan Gibbs (*Head of Illustration: Edinburgh College of Art*)

- Ruth MacGilp (*Gallery Manager, Coburg House*)

- Zakia Moulaoui (*Founder: Invisible Cities*)

- David Patterson (*Curatorial and Conservation Manager: Museums and Galleries, Edinburgh*)

I thank Sheila Stickley and Niall Mansfield at UIT / Green Books for their enthusiasm and continued support for *The City Art Book* Series.

To my husband Craig Bennett, thank you for always offering encouragement (and curry or coffee when needed). To Molly and William, I am so proud of you both. Thanks to my Mom, Toni, Great Aunty Jean, Len and Val and all the Bennett/Birch family.

Thanks to all my lovely friends for general book ramblings and support (special nod to Lynn Fraser, Emma Ayling and to Sarah Ramsey for help early on). Thank you to Sarah Maddocks for always listening. Thanks to chief proof reader Alison Schuldt, David Patterson and The City Arts Centre and Peter Bourhill for his knowledge of all things Edinburgh. 'Cheers' to Helen Brown for letting me share your 'Stair' for a night, the speedy tour of Edinburgh and for the Leith gig.

CONTENTS

FOREWORD

This is the city I have lived and worked in all my life. Edinburgh is a place of many moods, of northern skies, of jagged stone and warm hearths. It is a city where old meets new, where tangled medieval buildings neighbour neoclassical splendour. It is the home of the eighteenth century's Enlightenment but also present day inequalities. Here history and fiction walk side by side. Geographically it is a city sculpted by both fire and ice, with topography that rises and falls like an angry sea. From the vantage points of Castle Rock or Arthur's Seat, the terrain plunges down to the valleys of Dean or Colinton, the fluctuations in height providing sudden and dramatic views peeped through archways and closes, or grandly framed by wide Georgian streets. Turning north, one looks toward Fife and the Lomond Hills; east where on a clear day the Bass Rock shines white against deep blue; or south towards the Pentlands Hills, glowing eerily through a winter haar. It is a city that has inspired writers, poets and artists for centuries, no more so than today.

I am delighted to introduce *The Edinburgh Art Book*, celebrating the best city in the world. In this volume and accompanying map, we are taken on a journey through Edinburgh, following in the footsteps of her artists and seeing the multifaceted capital through their eyes. Through the work of the 67 contributing artists we are invited to revel in the beauty of Edinburgh, to view familiar scenes afresh, but more importantly explore the city from unique, undiscovered perspectives.

Here we celebrate Edinburgh's dynamism, her intrigue and her vibrant spirit. Congratulations to the selection panel and the artists: this carefully curated selection of work has led even a seasoned native like me to see Edinburgh anew. And to Edinburgh herself – Lang may yer lum reek!

Tommy Zyw
Director, The Scottish Gallery, Edinburgh

PREFACE

If you stand at the top of Castle Hill in Edinburgh and look out, what you will see is a well-constructed picture. The North Sea provides a background of blue, whilst the foreground is made up of a mosaic of slate rooftops, old tenement buildings and industrial warehouses mixed with transport hubs, green spaces and contemporary architecture. Throw in a castle and streets alive with music and non-stop festivals and you have the unique masterpiece that is Edinburgh.

The Edinburgh Art Book shows the city through the eyes of 67 artists it inspires. Familiar scenes and iconic buildings are interpreted in different ways using a range of media and styles. Look at the city through the eyes of its artists – look at the details they have seen – and you are sure to discover something new.

Local Edinburgh folk will see fresh interpretations of the familiar in the pages of this book, whilst visitors and tourists will be inspired to climb Edinburgh's famous steps or walk the cobbled streets to stand in the footsteps of an artist. It's all here to see – from the vibrant streets you'll find on a walk out to Leith over to the amazing bridges that span the Firth of Forth.

The Edinburgh Art Book is the third in the City Art Book Series (which includes *The Cambridge Art Book* and *The Oxford Art Book*) and represents just some of the talented artists working in Edinburgh and around. Have a look at the credits section in the back to find out about the artists and their work. Hopefully you will find yourself inspired to explore further both the artists and their city.

Emma Bennett
Editor

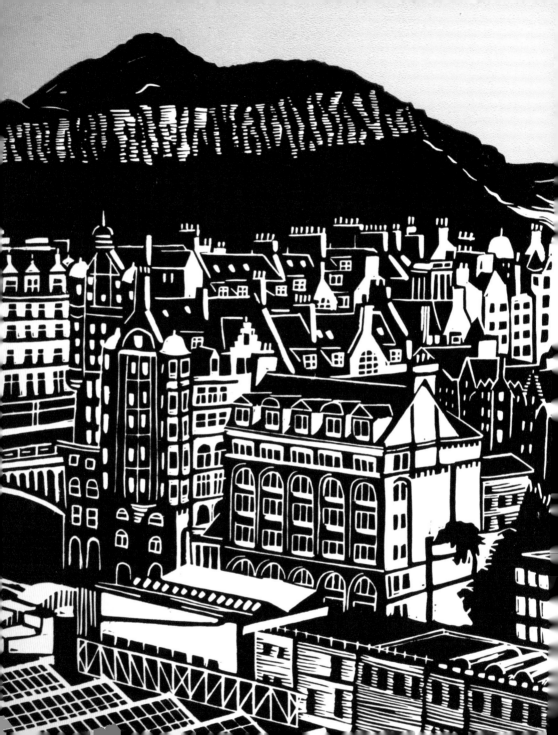

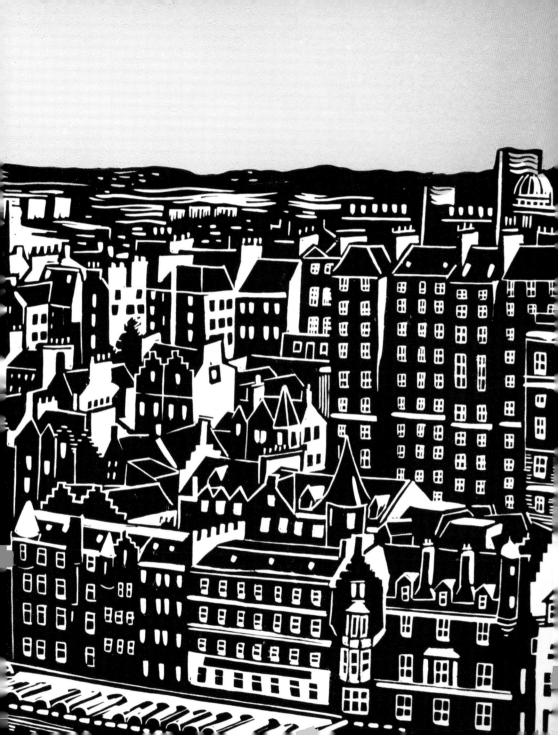

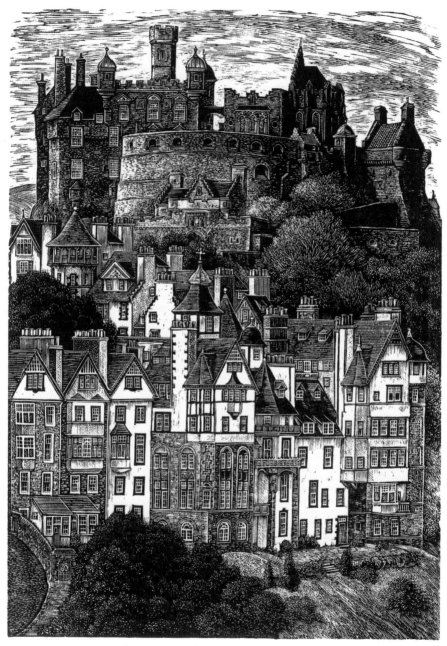

EDINBURGH CASTLE, SUE SCULLARD
PREVIOUS TWO PAGES: OLD TOWN, VIEW FROM SCOTT MONUMENT, MARIA DOYLE

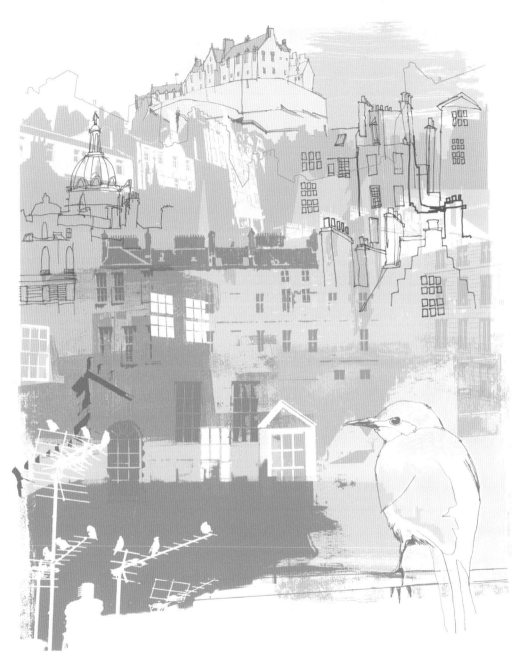

EDINBURGH CASTLE, KATE MILLER

11

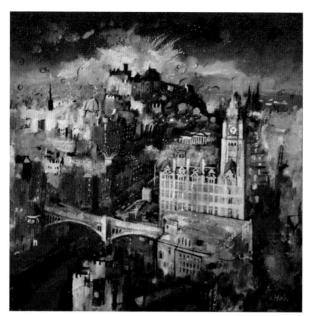

EDINBURGH CASTLE FROM CALTON HILL, ROB HAIN

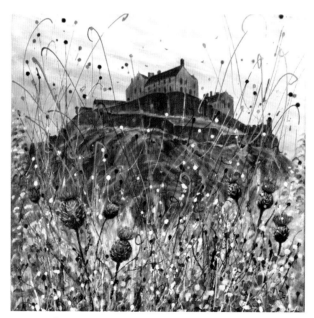

EDINBURGH CASTLE, PAM MCKENZIE

12

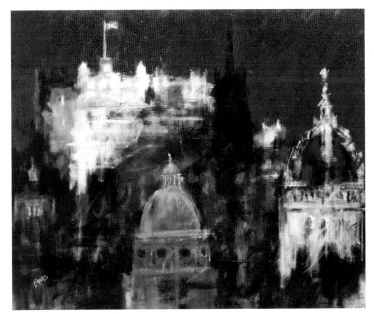

EDINBURGH FROM THE EAST, ALASDAIR BANKS

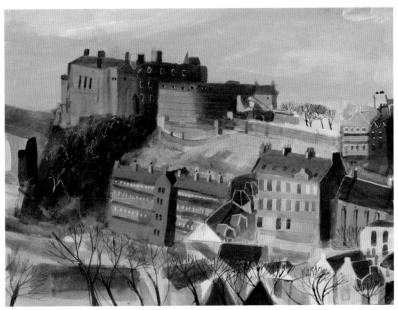

EDINBURGH CASTLE, JANE ASKEY

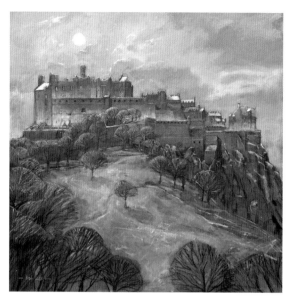

EDINBURGH CASTLE, BOB LEES

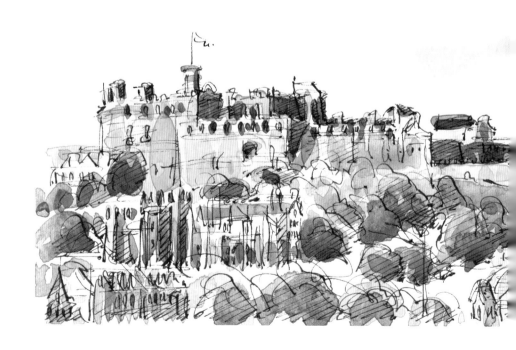

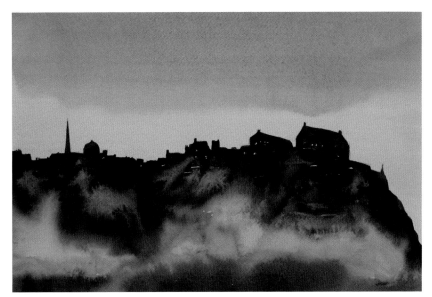

EDINBURGH CASTLE DARKNESS, ROSS MACINTYRE

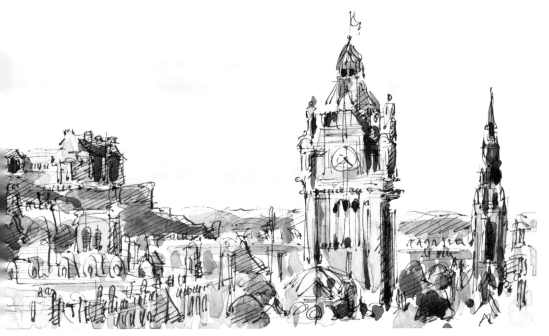

TOWARDS EDINBURGH CASTLE, RICHARD BRIGGS

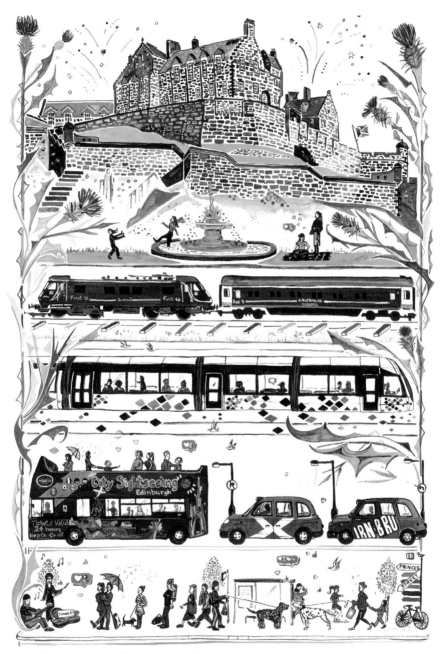

EDINBURGH CASTLE, LIBBY WALKER

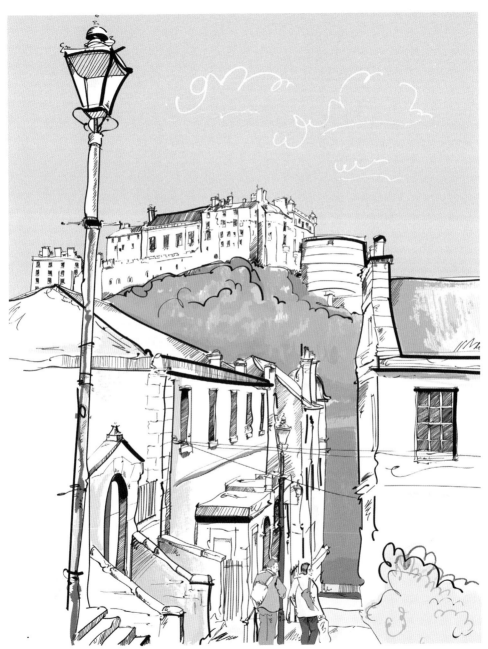

EDINBURGH CASTLE VIEW, ANNIE MAY ADAM
FOLLOWING TWO PAGES: EDINBURGH CASTLE, JONATHAN CHAPMAN

17

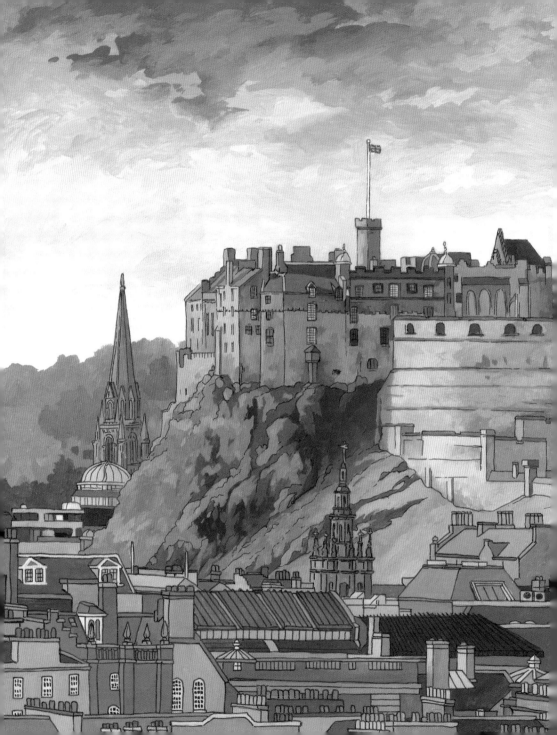

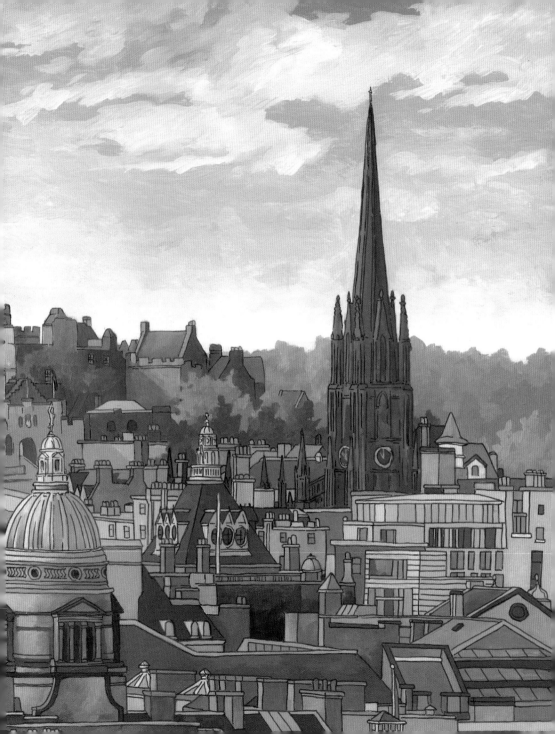

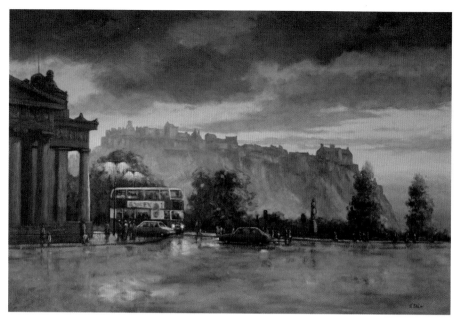

ROYAL ACADEMY AND EDINBURGH CASTLE, JOHN STOA

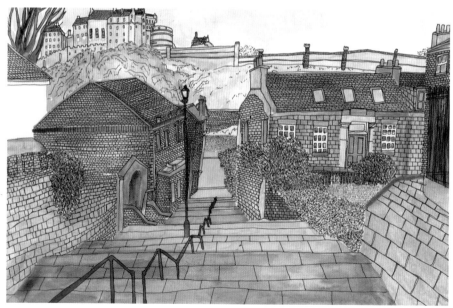

THE VENNEL, LAURA CAROLAN

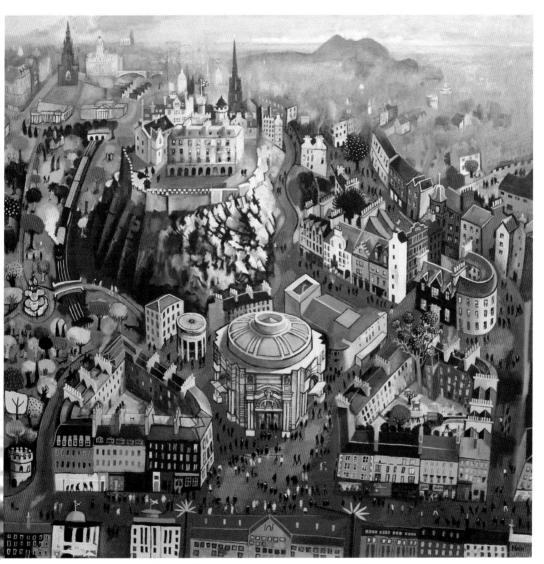

USHER HALL, LOTHIAN ROAD, ROB HAIN

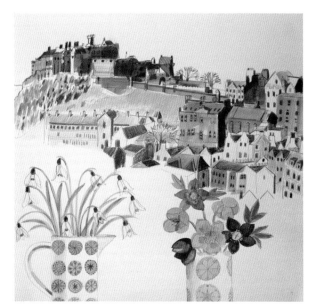

EDINBURGH CASTLE (WINTER), JANE ASKEY

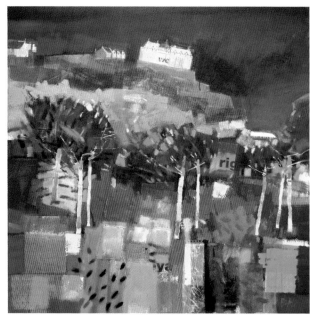

EDINBURGH CASTLE, FRANCIS BOAG

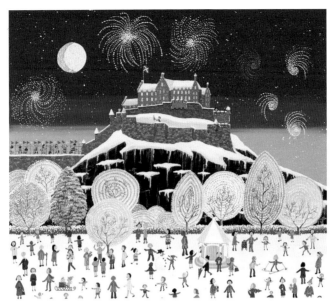

EDINBURGH CASTLE FIREWORKS, LYNN HANLEY

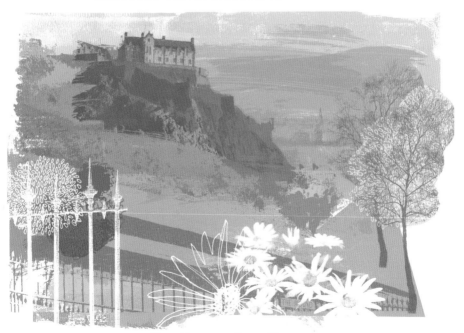

THE MOUND, KATE MILLER

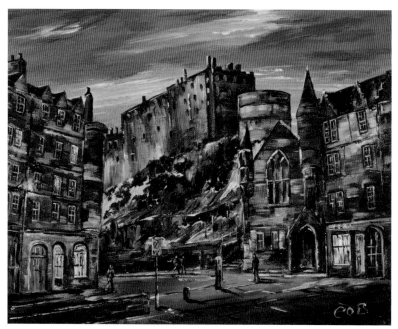

THE GRASSMARKET, COLM O'BRIEN

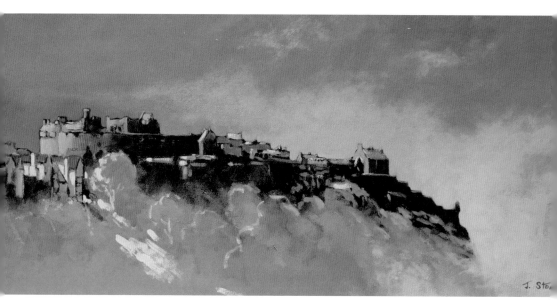

EDINBURGH CASTLE, JOHN STOA

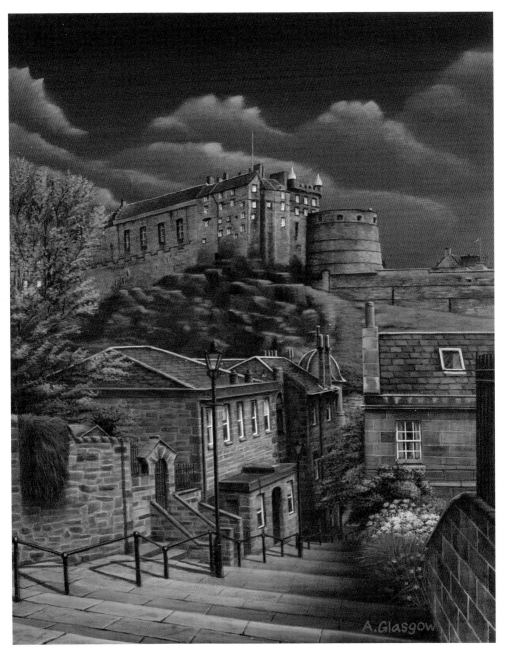

THE VENNEL, ALAN GLASGOW

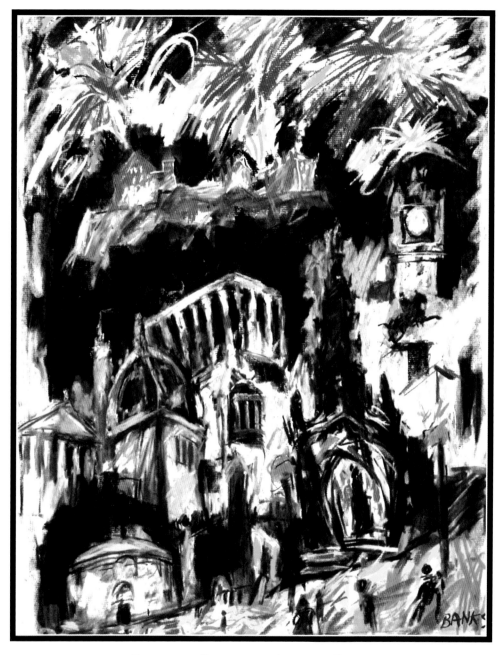

EDINBURGH FIREWORKS, ALASDAIR BANKS

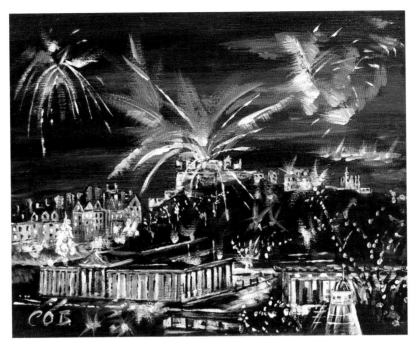

FIREWORKS AT EDINBURGH CASTLE, COLM O'BRIEN

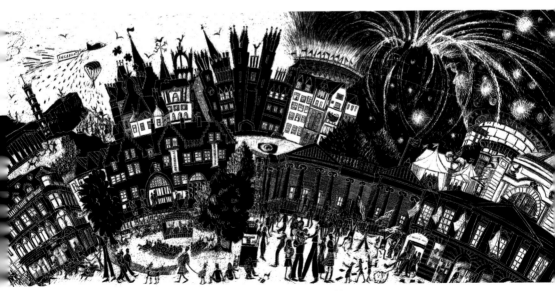

EDINBURGH FESTIVAL, CLAIRE HEMINSLEY

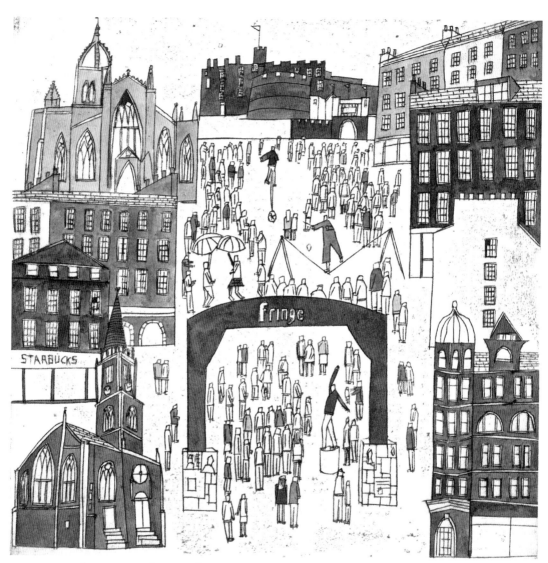

EDINBURGH FRINGE FESTIVAL ON THE ROYAL MILE, SALLY J FISHER

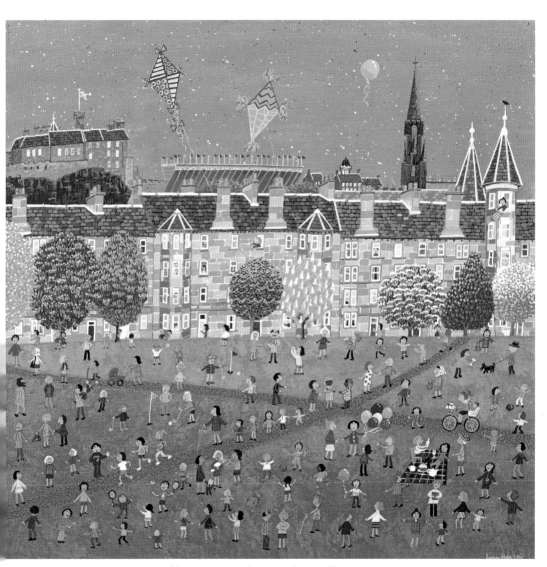

MARCHMONT LINKS, LYNN HANLEY

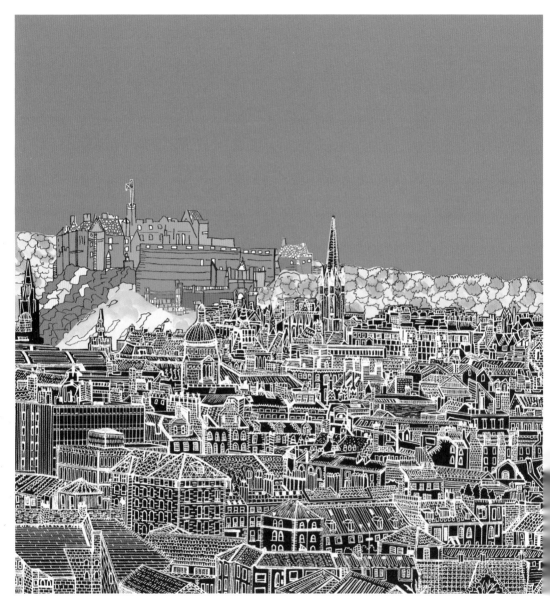

OVER THE TOP OF EDINBURGH, EMMA BENNETT

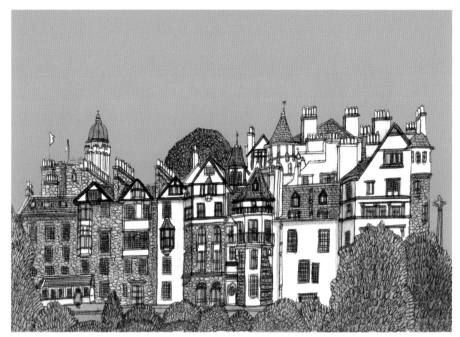

RAMSAY GARDEN, ADRIAN B McMURCHIE

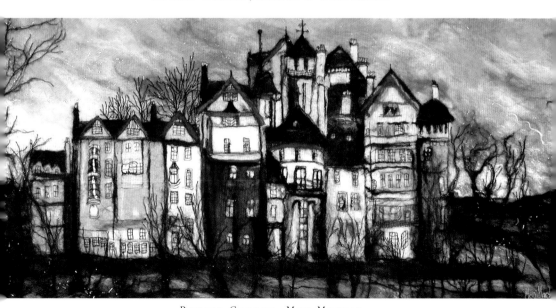

RAMSAY GARDEN, MOY MACKAY

31

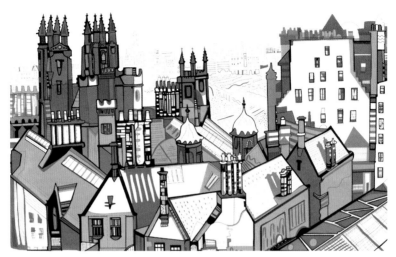

OBSCURA VIEW, SUSIE WRIGHT

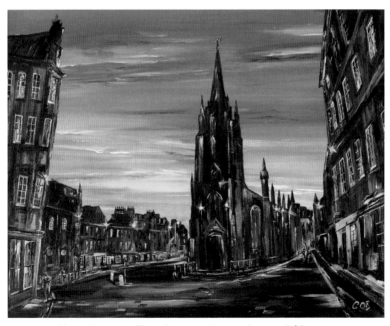

THE HUB ON THE ROYAL MILE, COLM O'BRIEN

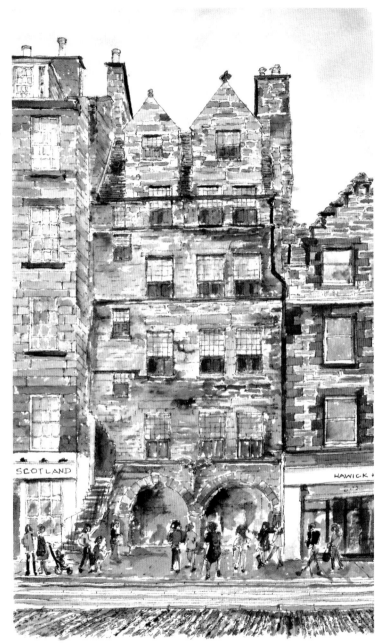

GLADSTONE'S LAND, FIONA MILLER

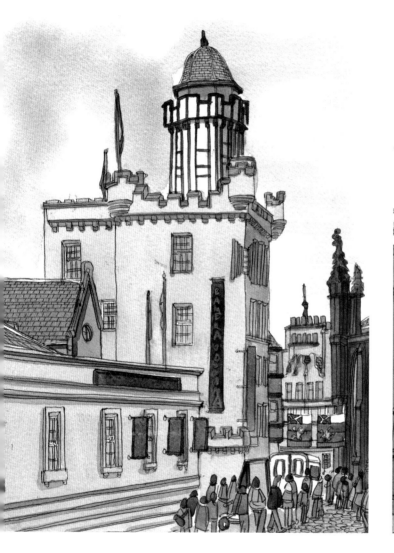
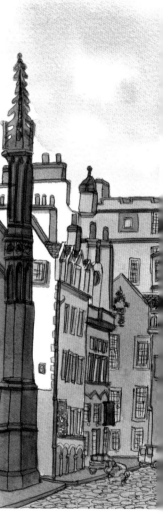

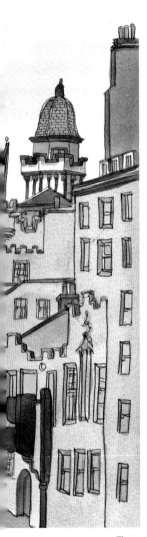
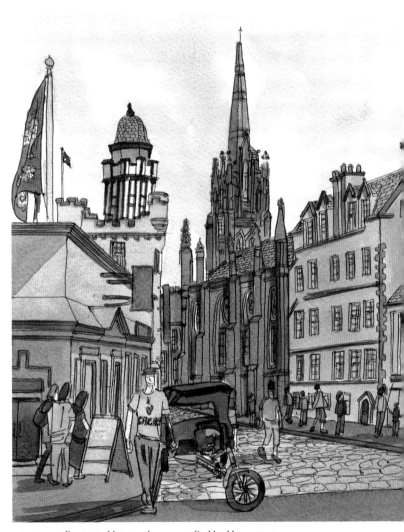

TAKE ME UP THE ROYAL MILE, ADRIAN B McMURCHIE

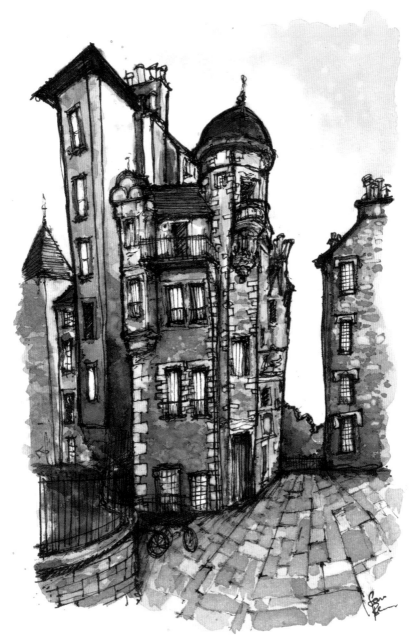

THE WRITERS' MUSEUM, SAM BLAIR

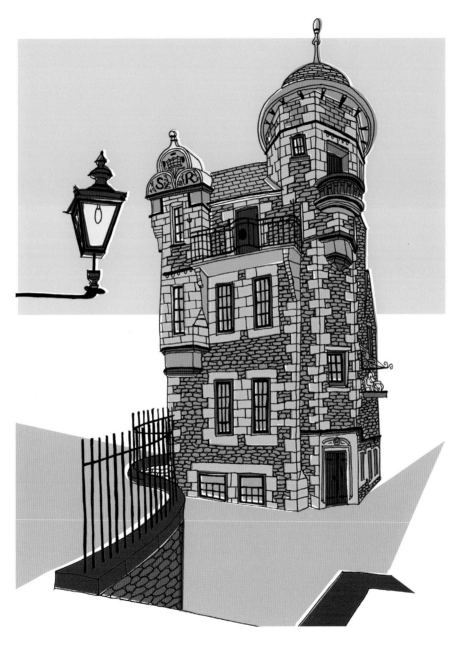

THE WRITERS' MUSEUM, YVETTE EARL

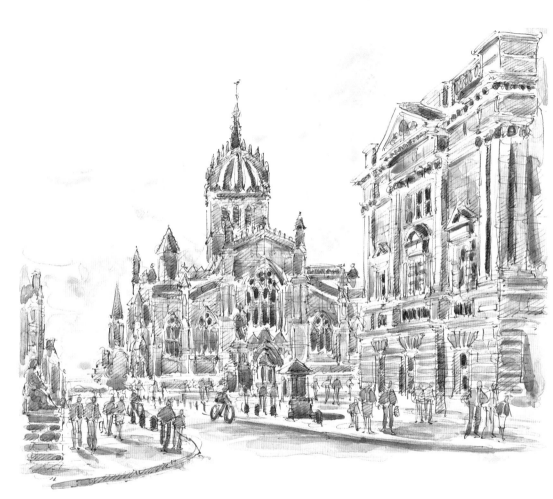

St Giles' Cathedral, Richard Briggs

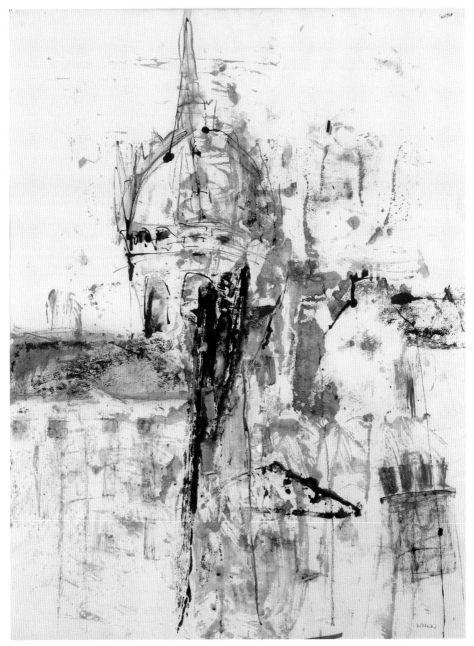

EDINBURGH OLD TOWN, KAREN WARNER

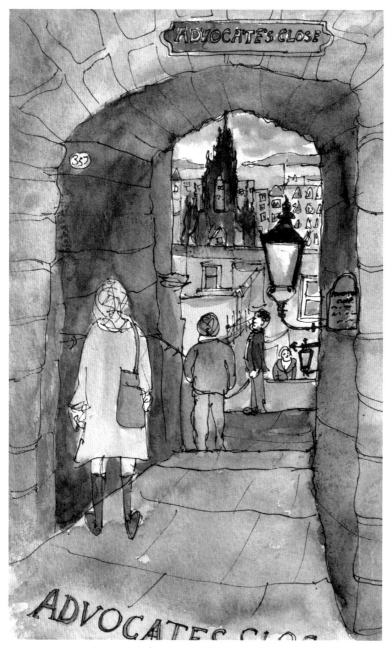

ADVOCATE'S CLOSE, SOPHIE MARTIN

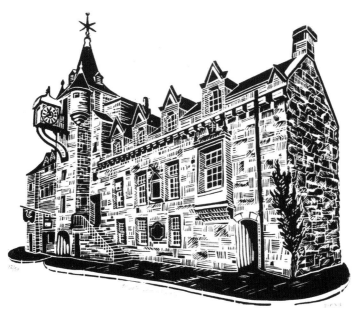

CANONGATE TOLBOOTH, THE ROYAL MILE, MARIA DOYLE

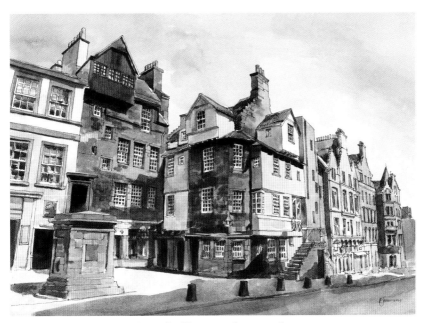

JOHN KNOX'S HOUSE, ESTHER SEMMENS

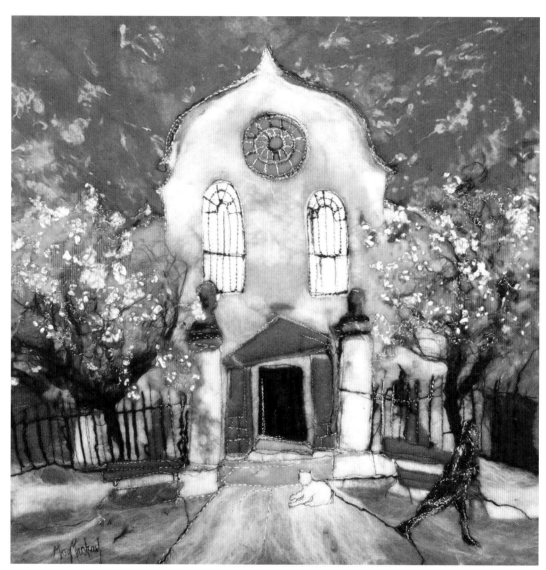

CANONGATE KIRK, MOY MACKAY

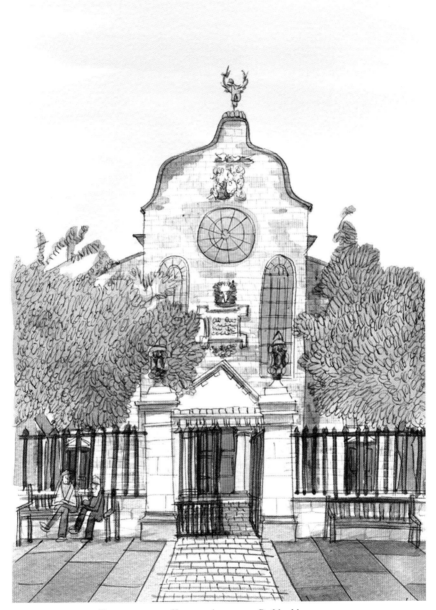

CANONGATE KIRK, ADRIAN B McMURCHIE

THE SCOTTISH PARLIAMENT, LIANA MORAN

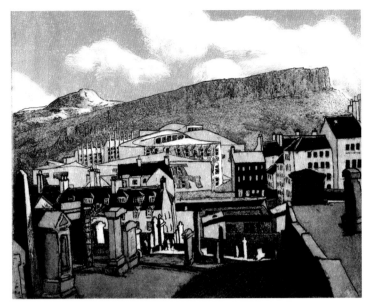

THE SCOTTISH PARLIAMENT (FROM REGENT'S ROAD), CAT OUTRAM

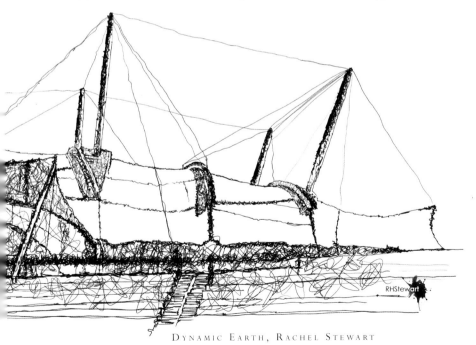

DYNAMIC EARTH, RACHEL STEWART

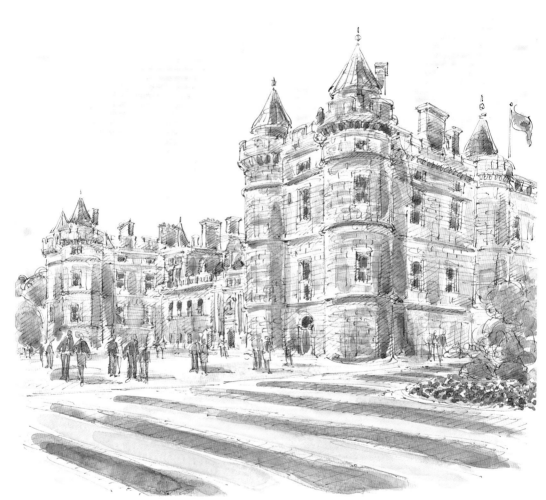

PALACE OF HOLYROODHOUSE, RICHARD BRIGGS

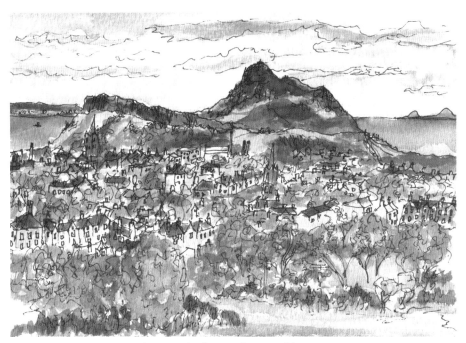

ARTHUR'S SEAT, SOPHIE MARTIN

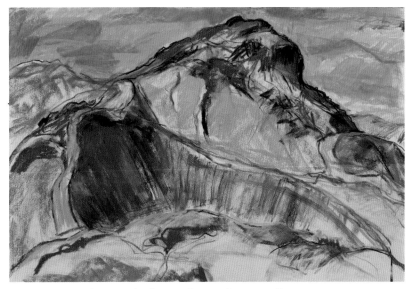

ARTHUR'S SEAT, EMILY INGREY-COUNTER

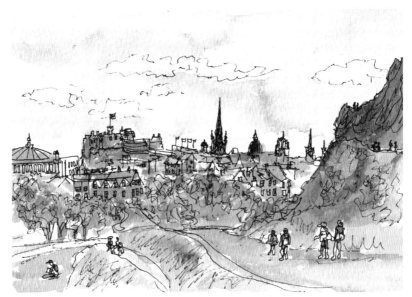

SALISBURY CRAGS, SOPHIE MARTIN

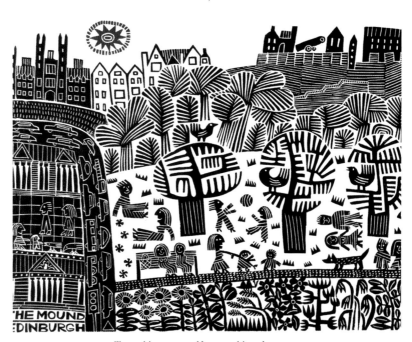

THE MOUND, HILKE MACINTYRE

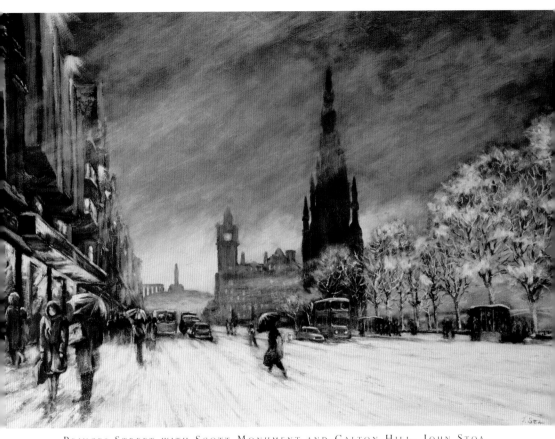

PRINCES STREET WITH SCOTT MONUMENT AND CALTON HILL, JOHN STOA

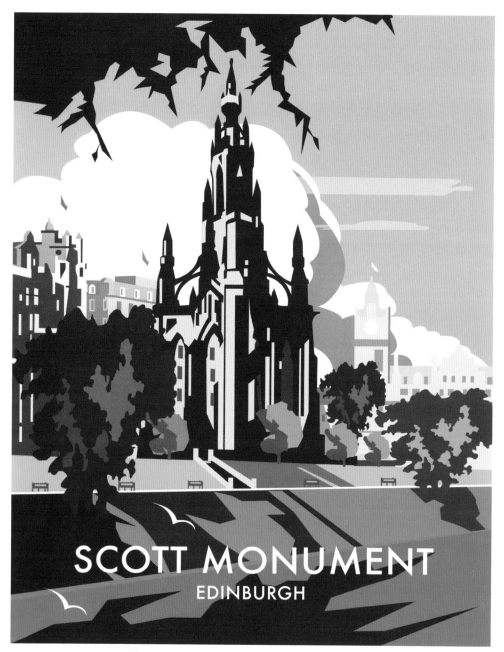

SCOTT MONUMENT

EDINBURGH

The Scott Monument, Dave Thompson

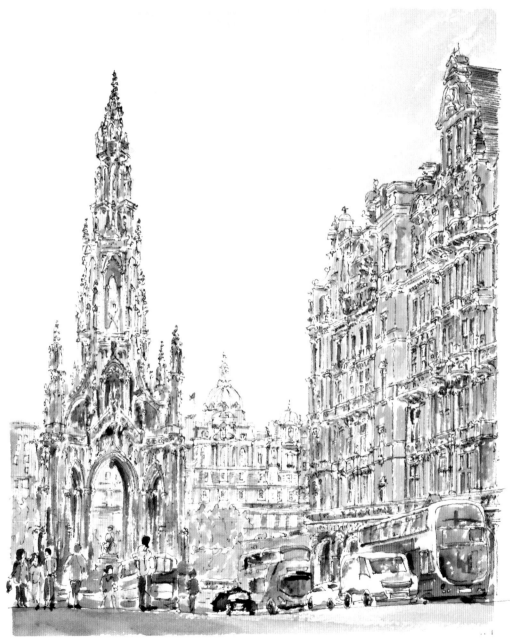

THE SCOTT MONUMENT, FIONA MILLER

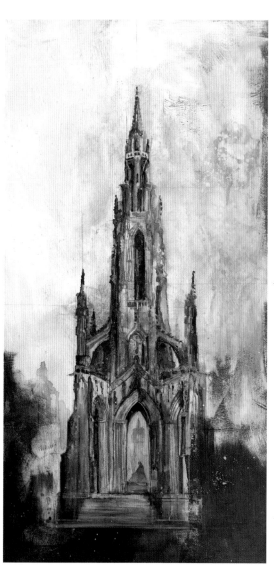

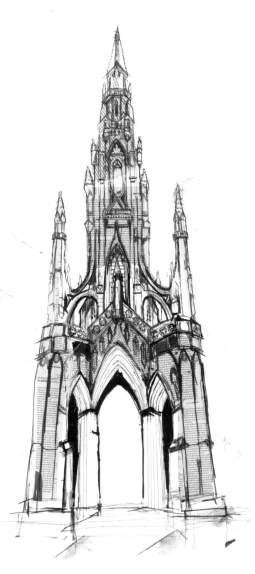

THE SCOTT MONUMENT, AMANDA PHILLIPS THE SCOTT MONUMENT, LIANA MORAN

52

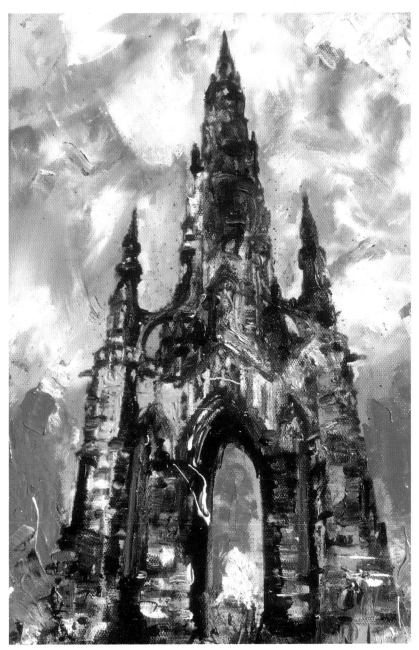

THE SCOTT MONUMENT, LIAM DOBSON

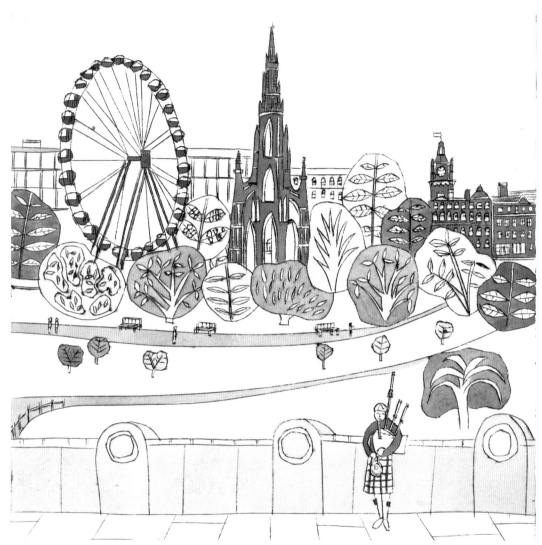

EDINBURGH PIPER AND THE SCOTT MONUMENT, SALLY J FISHER

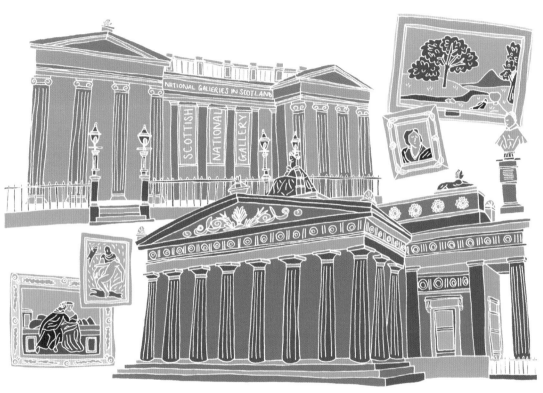

NATIONAL GALLERY, VICTORIA ROSE BALL

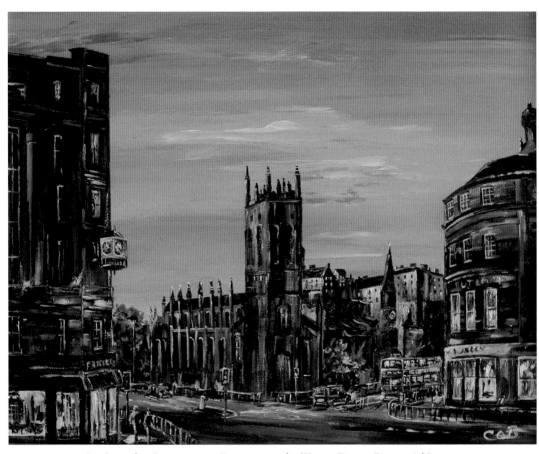

ST JOHN'S CHURCH IN EDINBURGH'S WEST END, COLM O'BRIEN

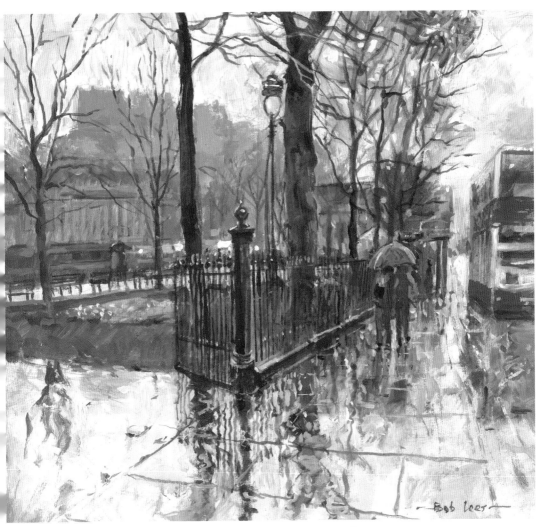

CASTLE FROM PRINCES ST, BOB LEES

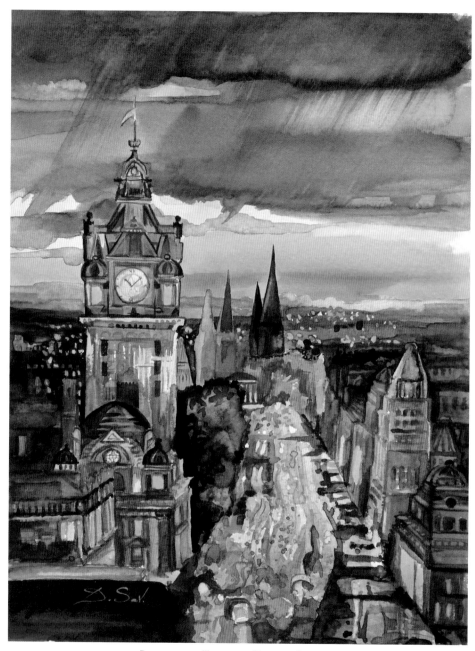

BALMORAL TOWER, DIANA SAVOVA

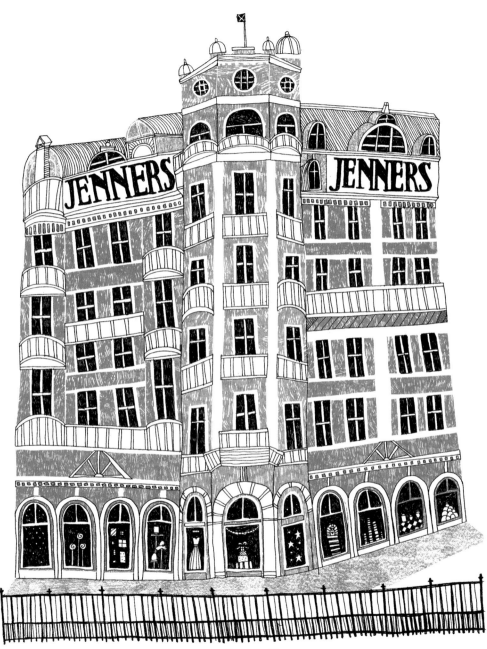

JENNERS, EILIDH MULDOON

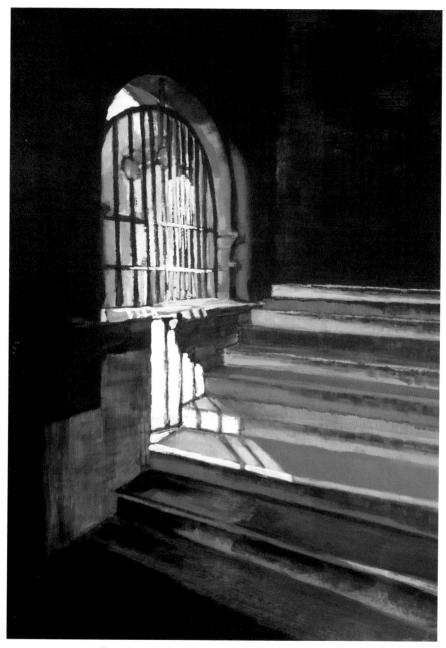

THE SCOTSMAN STEPS, LINDSEY LAVENDER

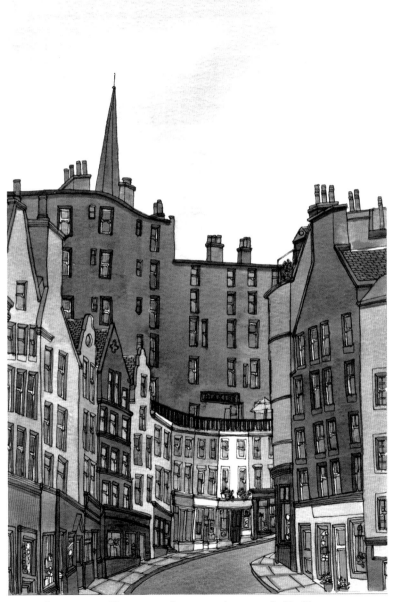

STROLL ON VICTORIA STREET, ADRIAN B MCMURCHIE

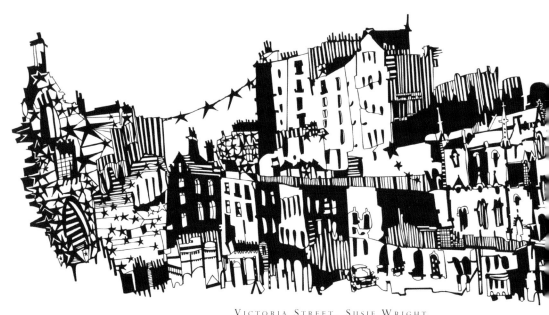

VICTORIA STREET, SUSIE WRIGHT

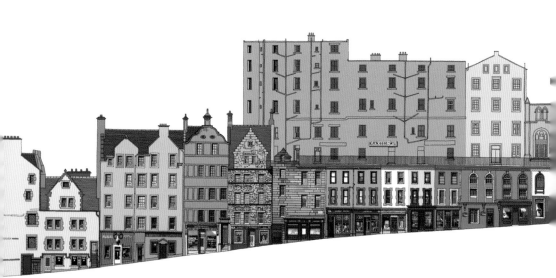

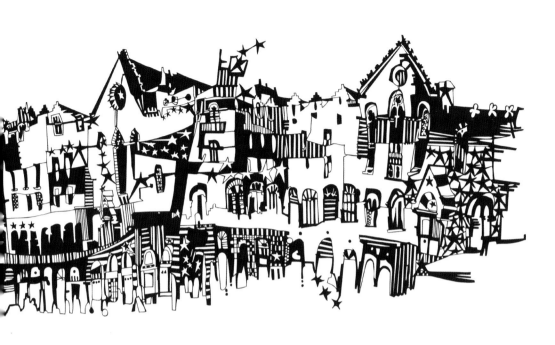

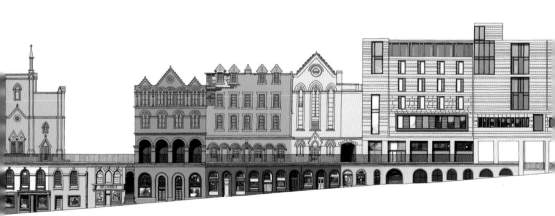

WEST BOW 2018, ANDREW SIDDALL

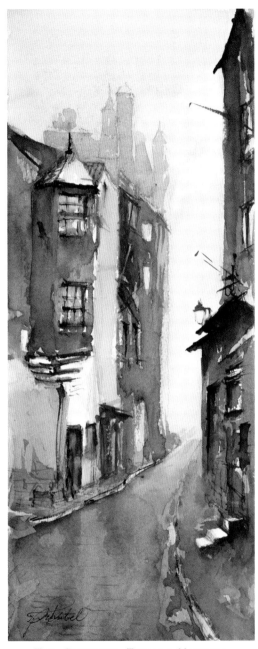

THE COWGATE, TOMASZ MIKUTEL

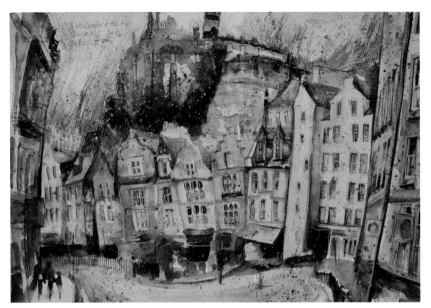

THE GRASSMARKET, BLYTHE SCOTT

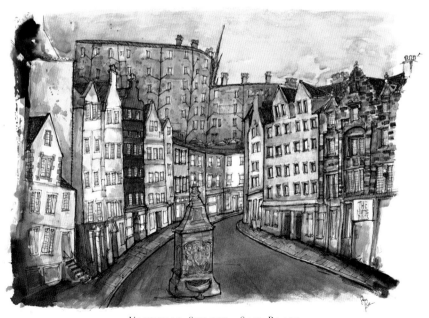

VICTORIA STREET, SAM BLAIR

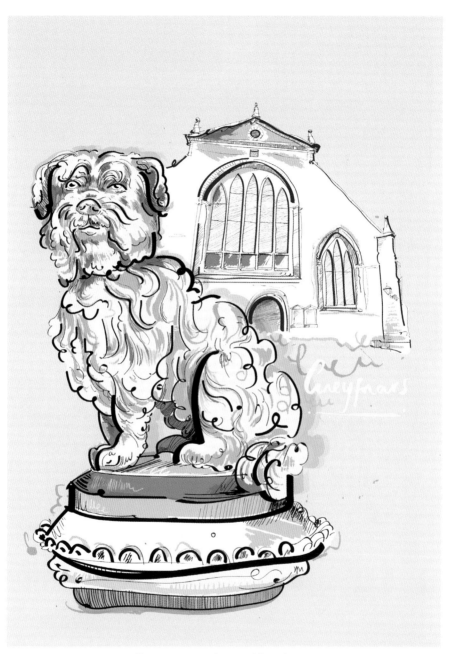

GREYFRIARS, ANNIE MAY ADAM

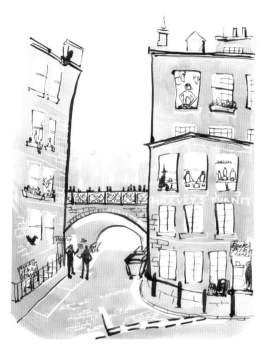

MERCHANT STREET, LUCY ROSCOE

NATIONAL MUSEUM OF SCOTLAND, VICTORIA ROSE BALL

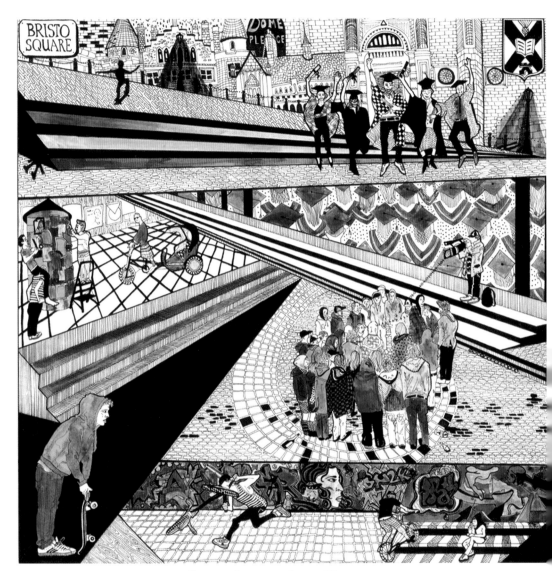

BRISTO SQUARE, LIBBY WALKER

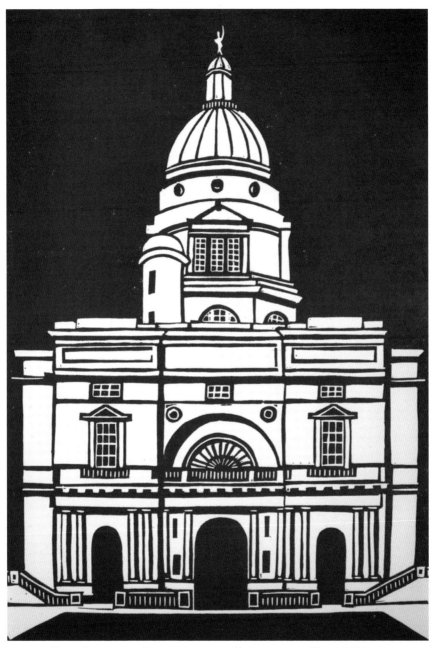

OLD COLLEGE, UNIVERSITY OF EDINBURGH, MARIA DOYLE

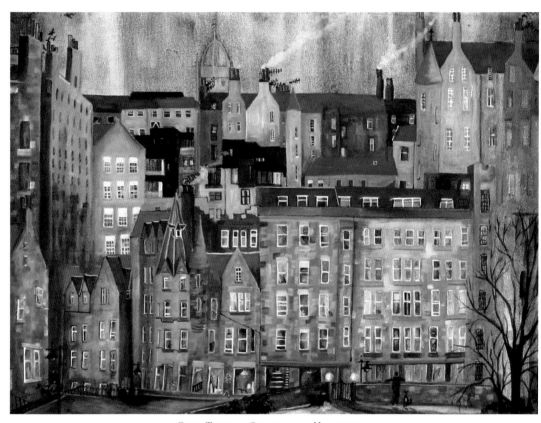

OLD TOWN, SHEENAGH HARRISON

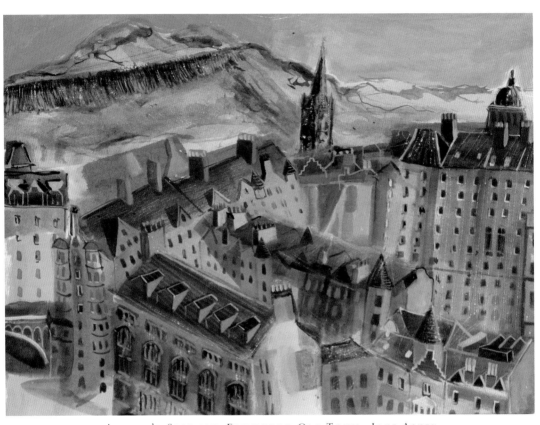

Arthur's Seat and Edinburgh Old Town, Jane Askey

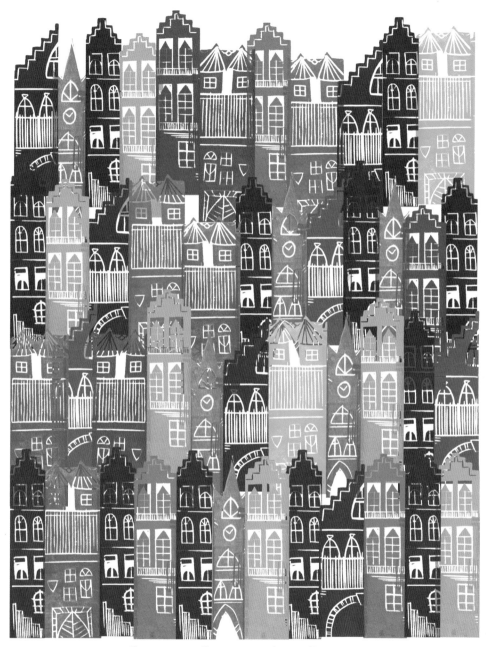

EDINBURGH CITYSCAPE, JENNI DOUGLAS
RIGHT: EDINBURGH, IAN SCOTT MASSIE

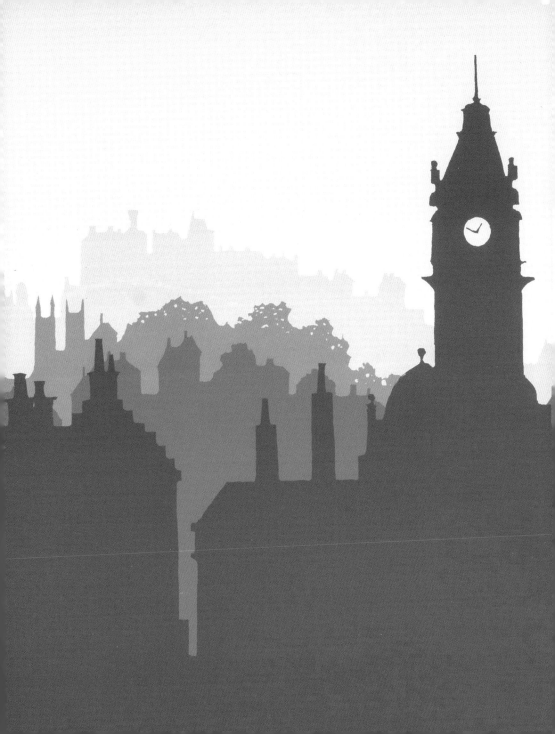

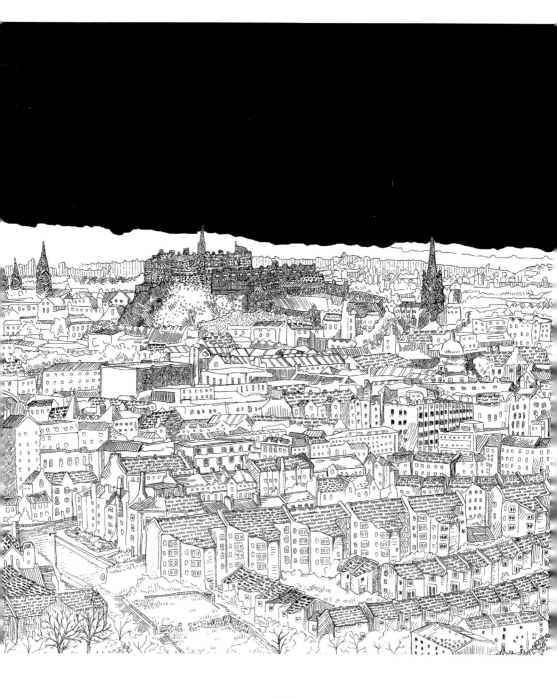

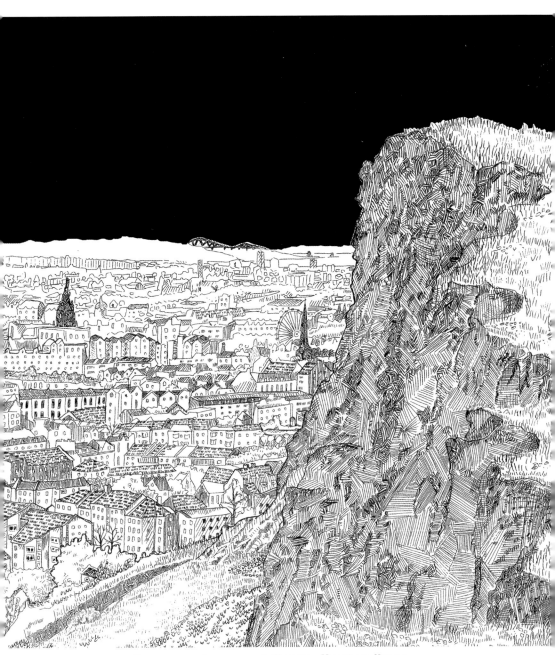

EDINBURGH SKYLINE AT NIGHT, HANNAH KELLY

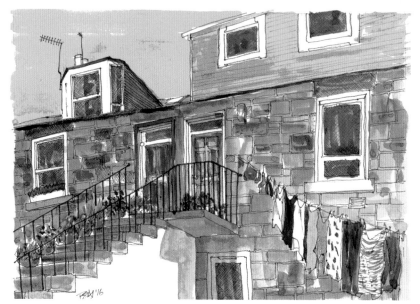

COLONY HOUSE, PAUL ISAACS

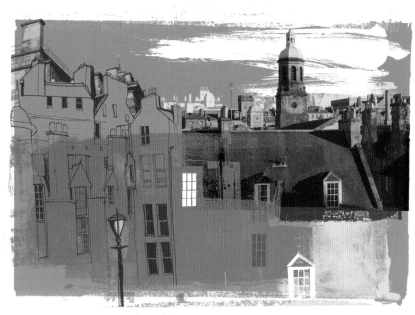

OLD TOWN, KATE MILLER

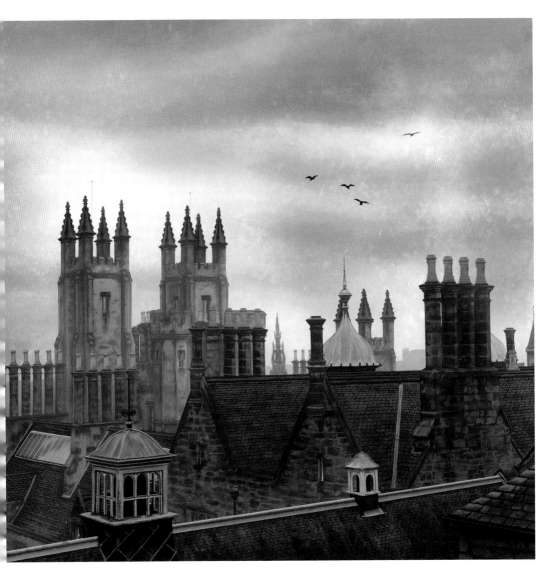

OLD TOWN, ANNA MIDDLEMASS

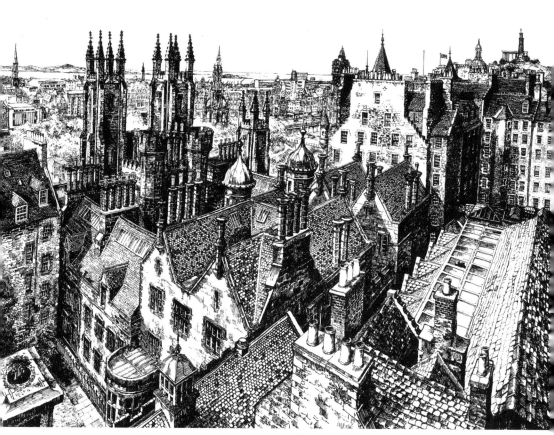

VIEW FROM THE OUTLOOK TOWER, SUE SCULLARD

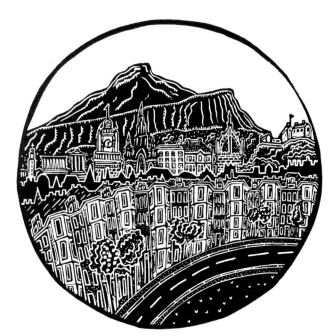

EDINBURGH, PAMELA SCOTT

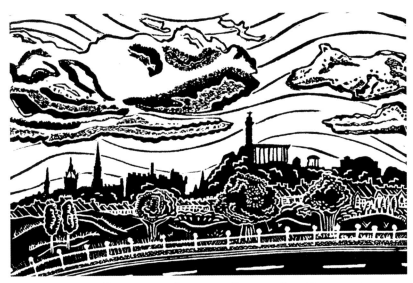

EDINBURGH SKYLINE, PAMELA SCOTT

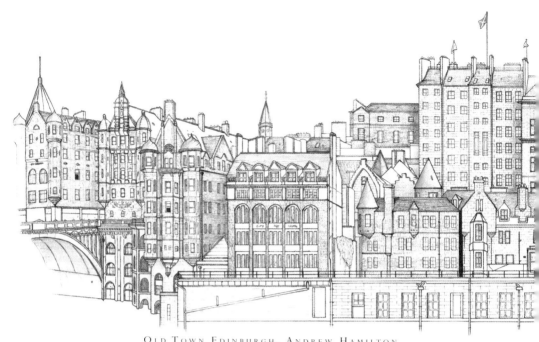

OLD TOWN EDINBURGH, ANDREW HAMILTON

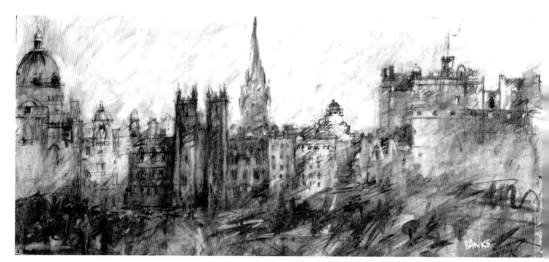

EDINBURGH (AFTER PIRANESI), ALASDAIR BANKS

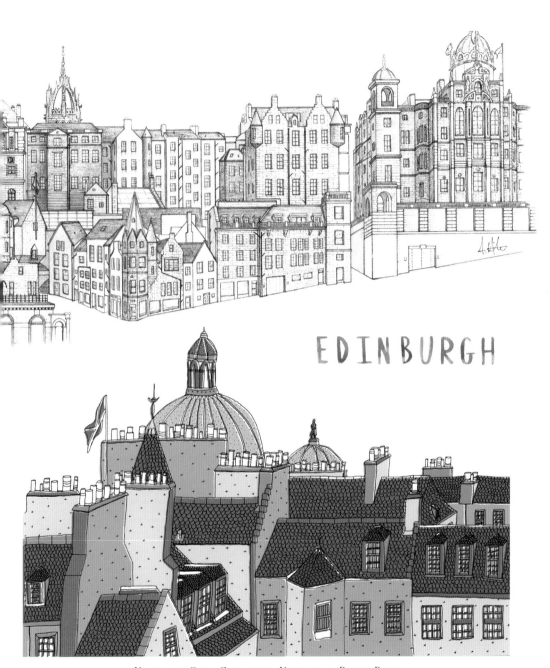

EDINBURGH

VIEW OF OLD COLLEGE, VICTORIA ROSE BALL

81

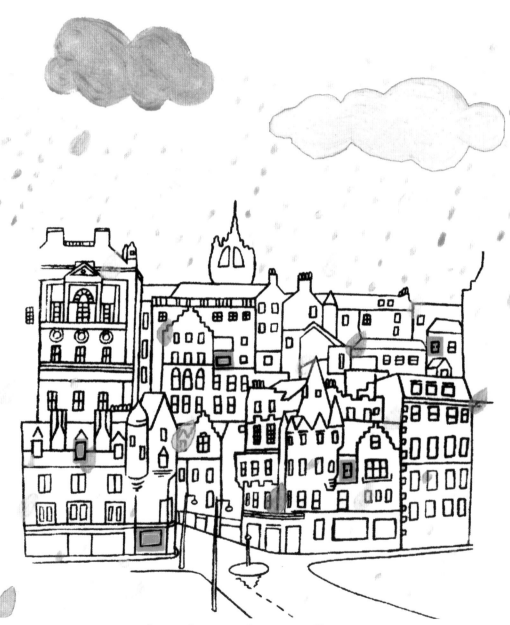

RAINY SKYLINE, CASSANDRA HARRISON

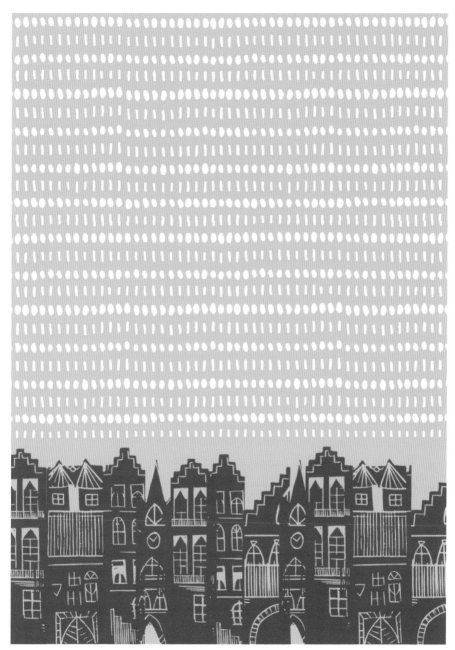

A N E D I N B U R G H D A Y , J E N N I D O U G L A S

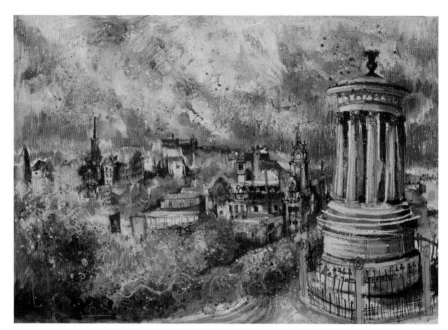

CALTON HILL, BLYTHE SCOTT

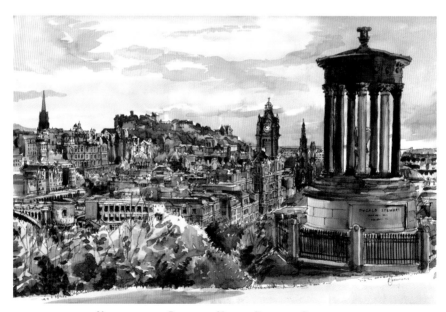

VIEW FROM CALTON HILL, ESTHER SEMMENS

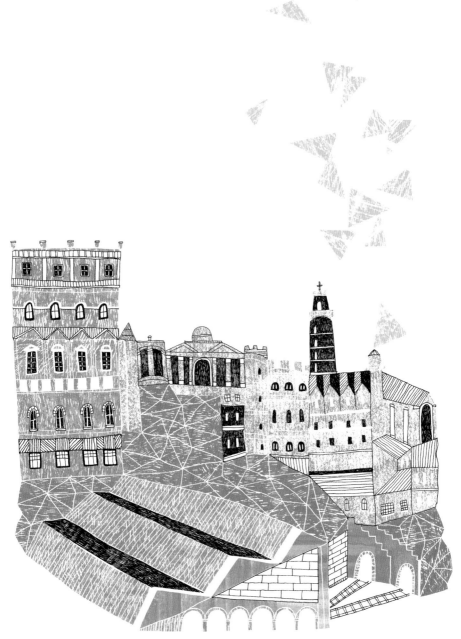

CALTON HILL, EILIDH MULDOON
FOLLOWING TWO PAGES: VIEW TO CALTON HILL, ESTHER SEMMENS

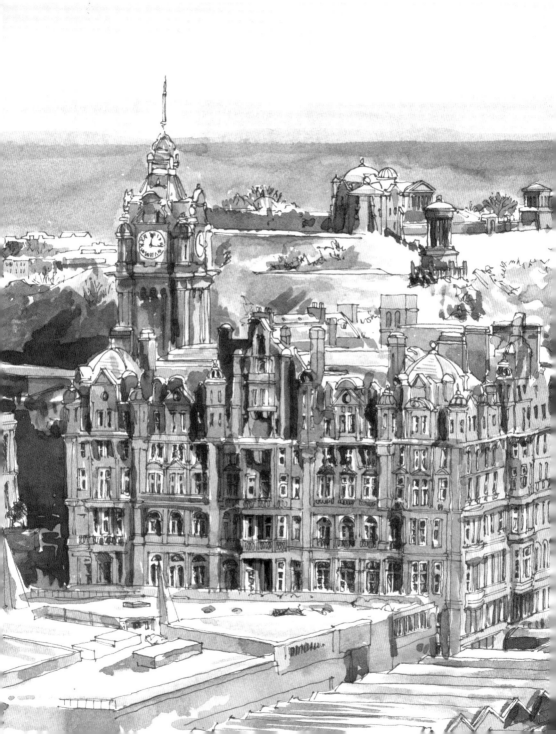

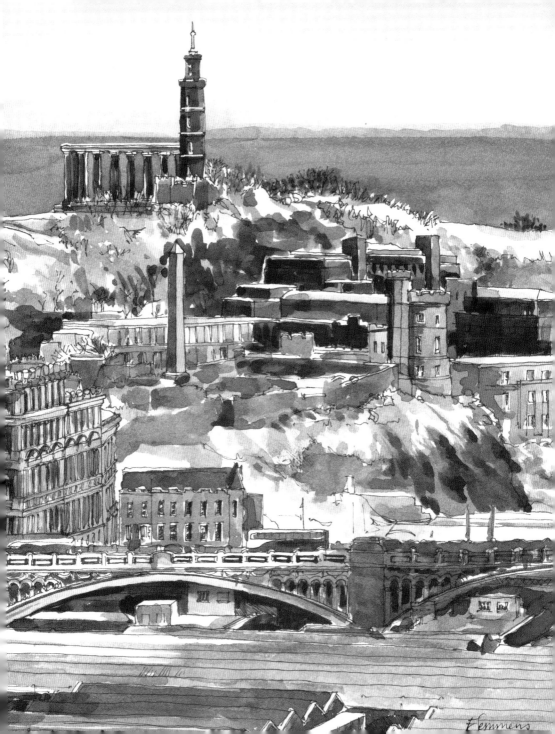

Hemmens

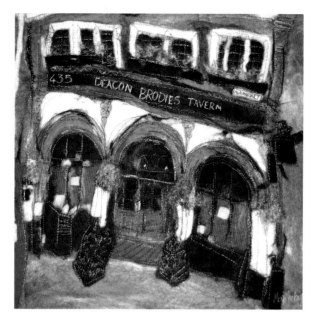

DEACON BRODIES, MOY MACKAY

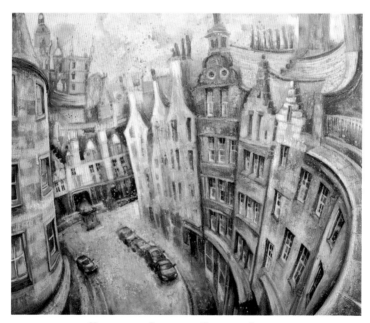

VICTORIA STREET, BLYTHE SCOTT

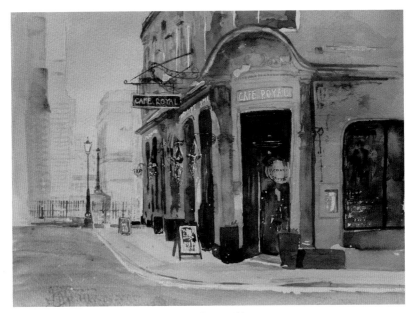

CAFE ROYAL, ROSS MACINTYRE

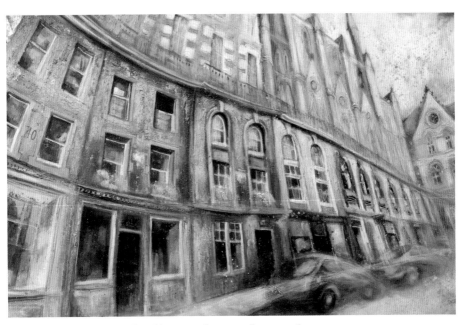

LA MAISON BLEUE, BLYTHE SCOTT

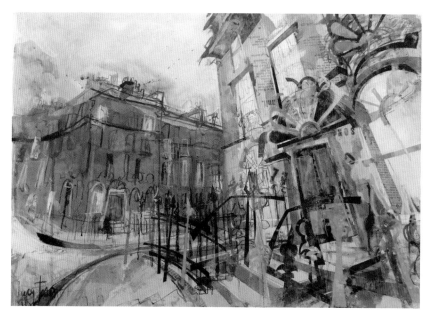

GREAT STUART STREET, LUCY JONES

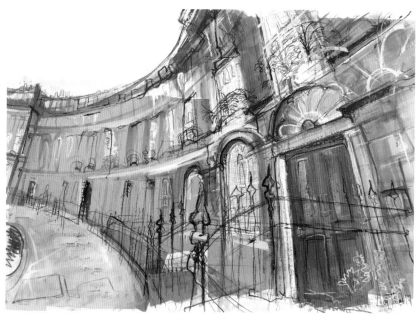

AINSLIE PLACE, LUCY JONES

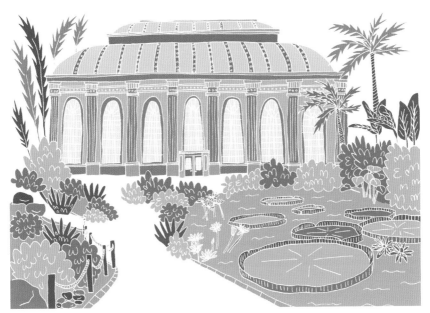

BOTANIC GARDENS, VICTORIA ROSE BALL

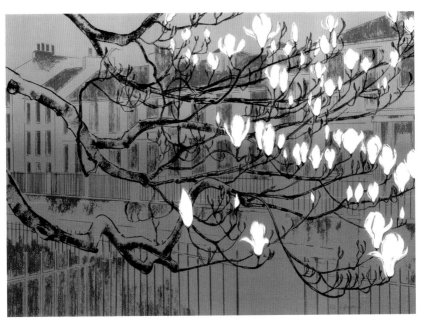

ANN STREET, LAURA GRESSANI

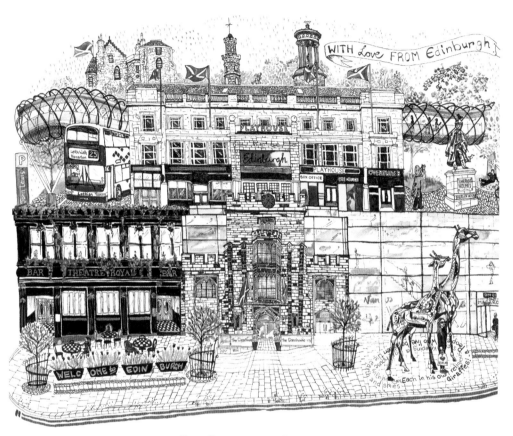

THE PLAYHOUSE, LIBBY WALKER

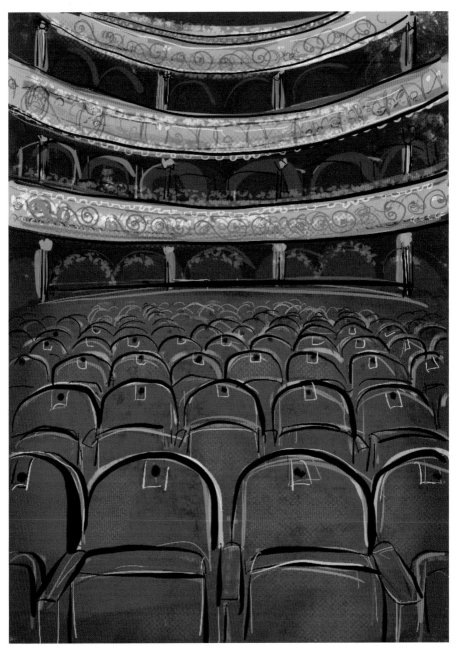

THE AUDITORIUM INSIDE THE LYCEUM THEATRE, GRINDLAY STREET,
LYDIA BOURHILL

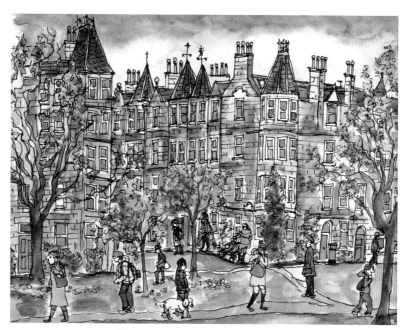

MARCHMONT, SOPHIE MARTIN

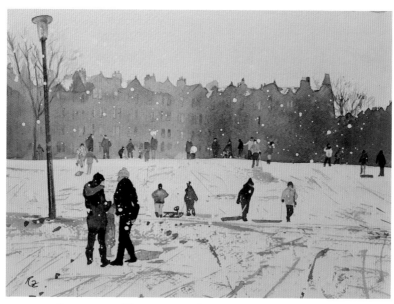

SLEDGING, WARRANDER PARK, ROSS MACINTYRE

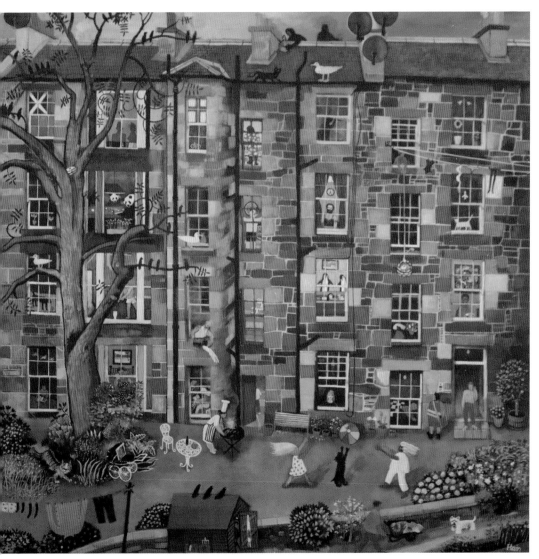

TOLLCROSS, TENEMENT BACK GREEN, ROB HAIN

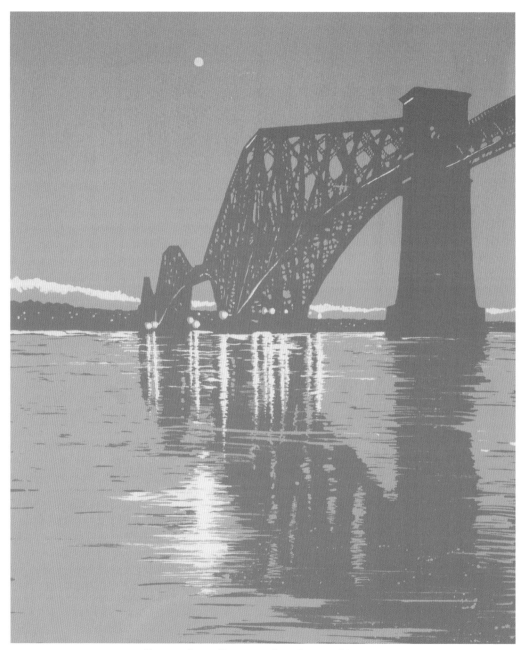

FORTH RAIL BRIDGE, IAN SCOTT MASSIE

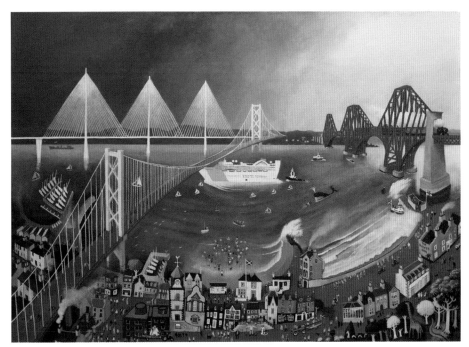

THE BRIDGES OF THE FORTH FROM SOUTH QUEENSFERRY, ROB HAIN

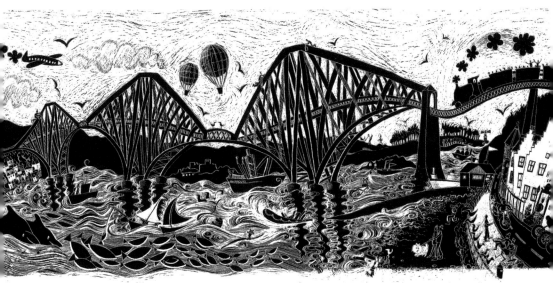

FORTH RAIL BRIDGE, CLAIRE HEMINSLEY

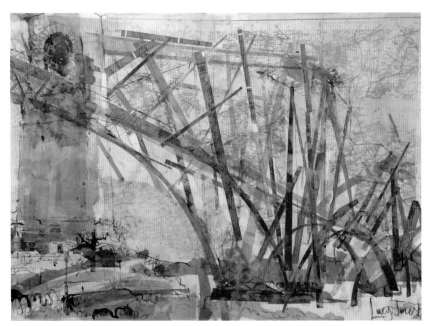

FORTH RAIL BRIDGE, LUCY JONES

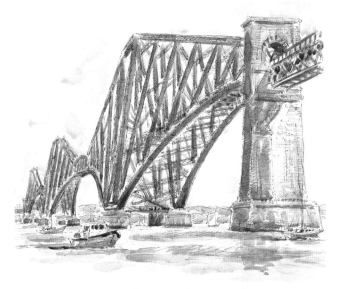

FORTH RAIL BRIDGE, RICHARD BRIGGS

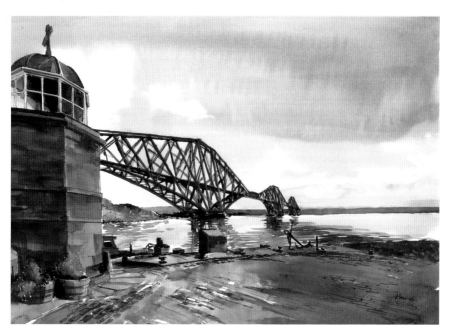

FORTH RAIL BRIDGE, ESTHER SEMMENS

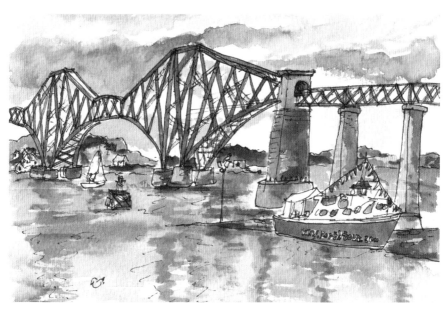

FORTH RAIL BRIDGE, SOPHIE MARTIN

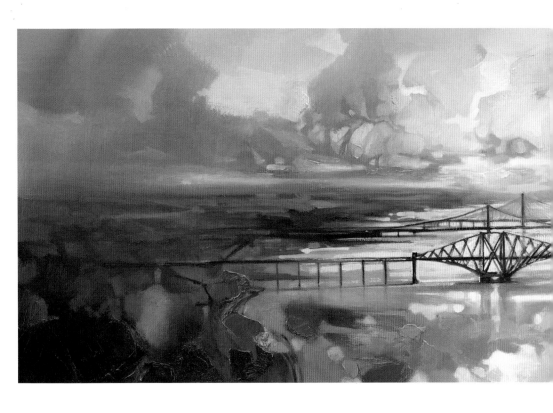

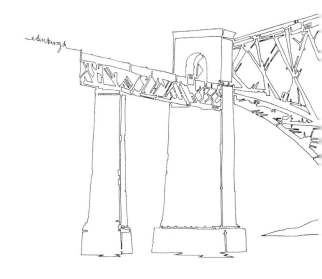

edinburgh

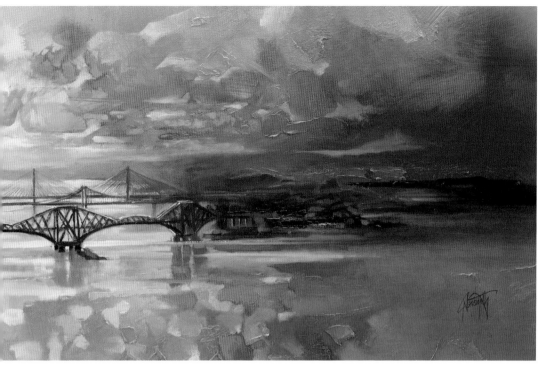

THREE BRIDGES, SCOTT NAISMITH

FORTH RAIL BRIDGE, DAVID HARDCASTLE

101

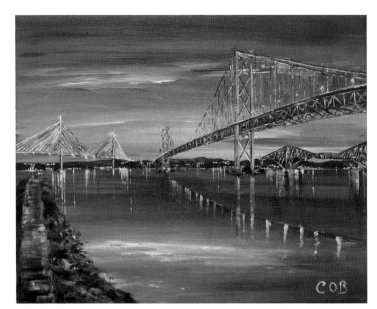

THE THREE FORTH BRIDGES, COLM O'BRIEN

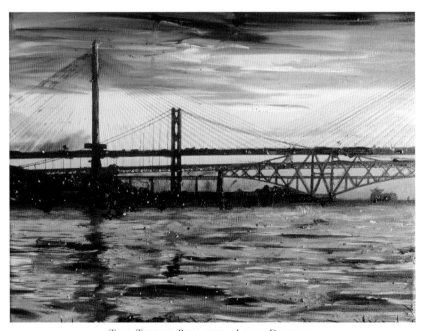

THE THREE BRIDGES, LIAM DOBSON

DEAN VILLAGE, REBECCA HESELTON

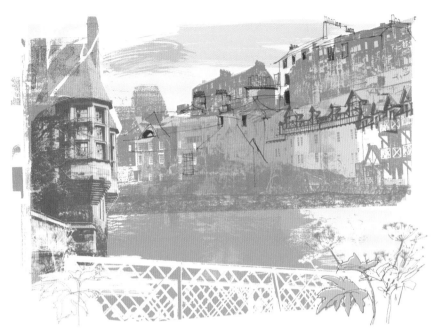

DEAN VILLAGE, KATE MILLER

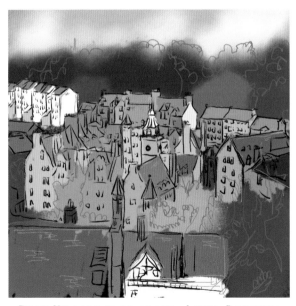

DEAN VILLAGE FROM ABOVE, LYDIA BOURHILL

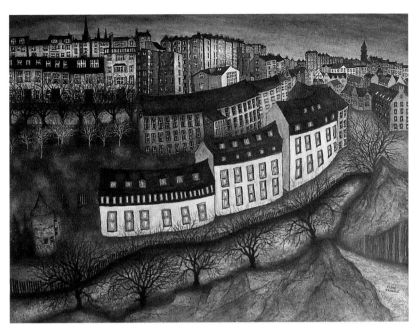

DEAN VILLAGE FROM THE DEAN BRIDGE, CLIVE RAMAGE

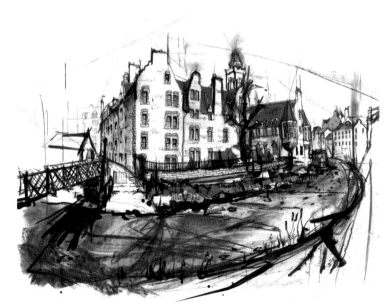

DEAN VILLAGE, LIANA MORAN

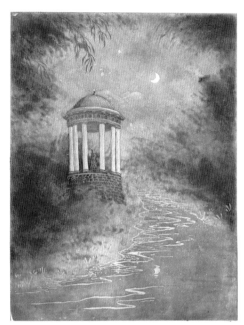

ST BERNARD'S WELL, KATRINE LYCK

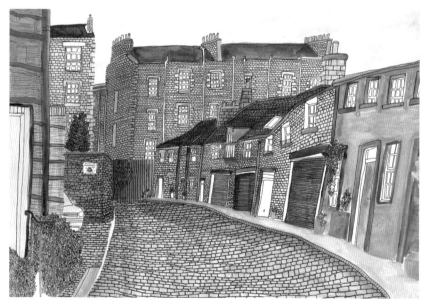

CIRCUS LANE, LAURA CAROLAN

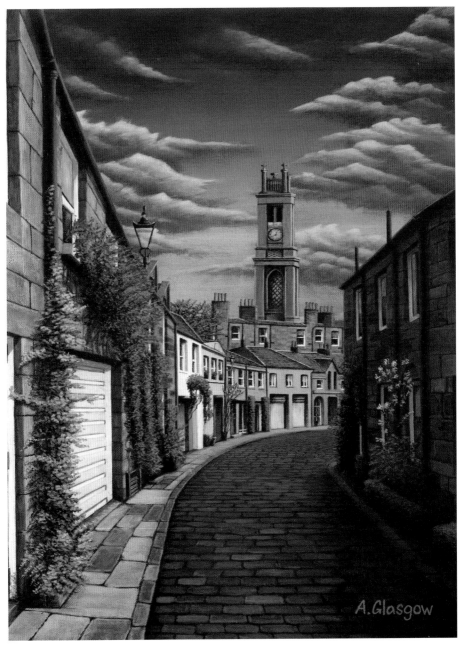

CIRCUS LANE, ALAN GLASGOW

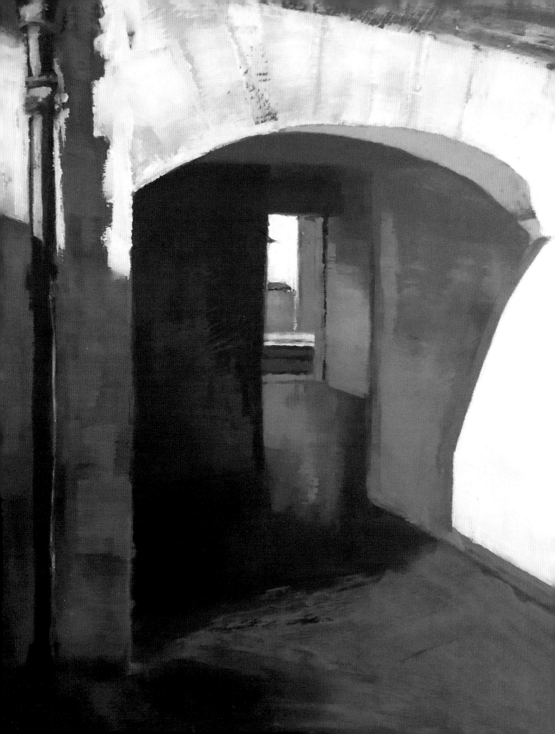

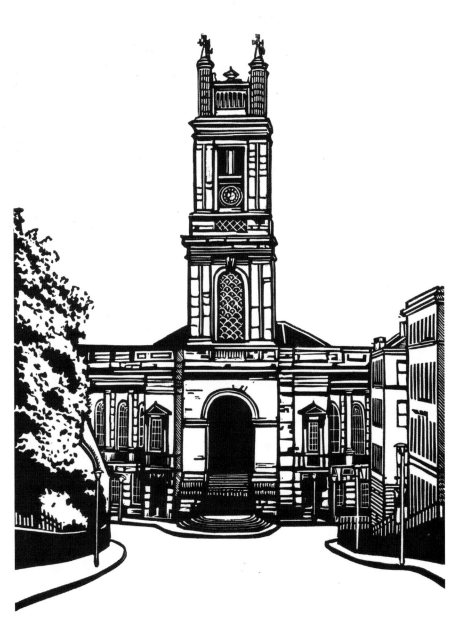

ST STEPHEN'S CHURCH, HUGH BRYDEN
LEFT: ST STEPHEN'S PLACE, STOCKBRIDGE, LINDSEY LAVENDER

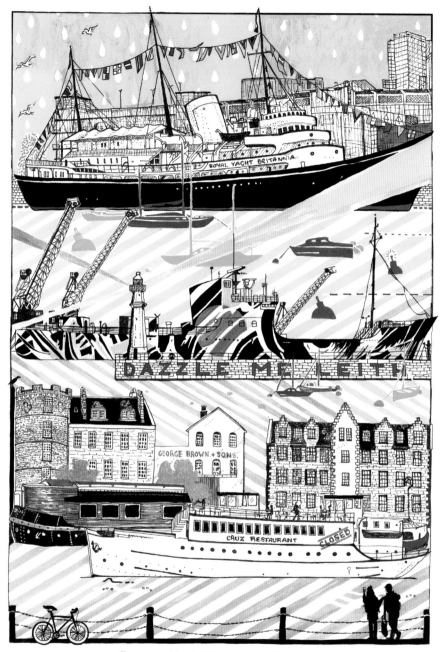

DAZZLE ME LEITH, LIBBY WALKER

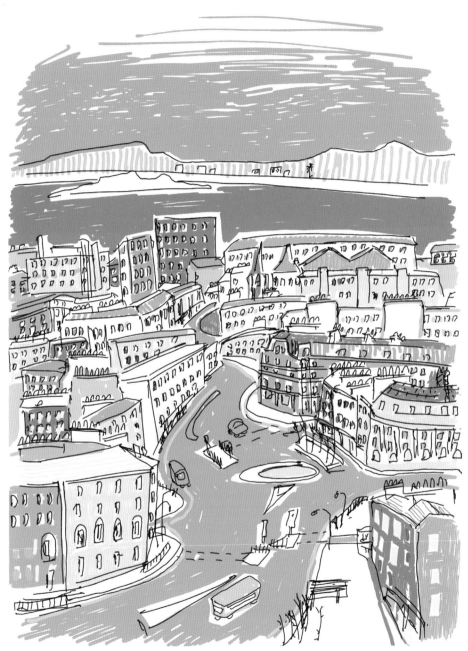

LEITH WALK, CASSANDRA HARRISON

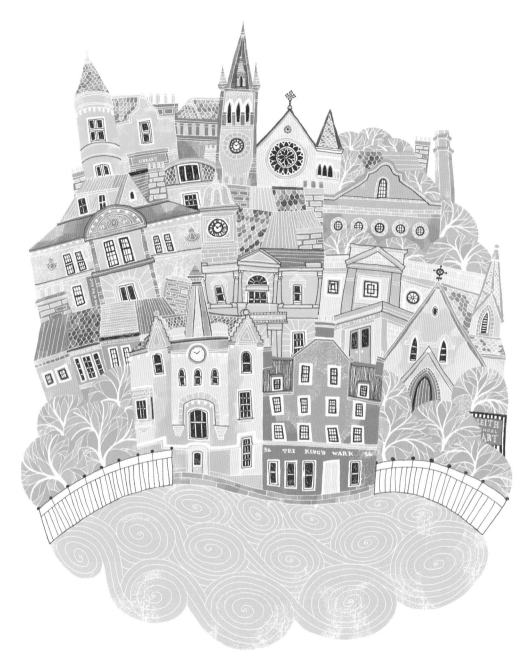

LEITH, EILIDH MULDOON

LEITH TOWERBLOCK, KAREN WARNER

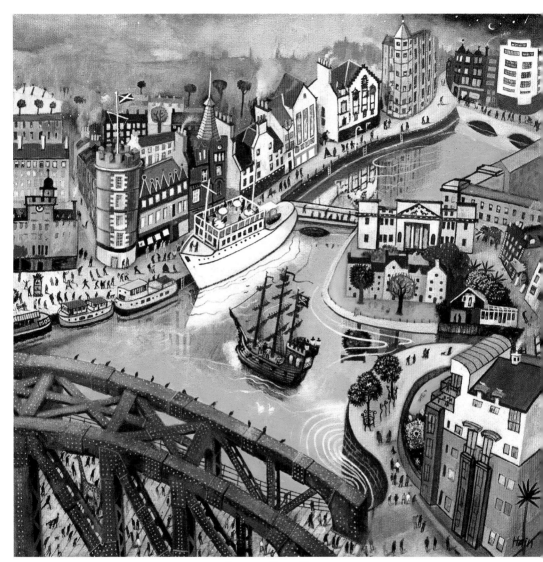

LEITH, ROB HAIN

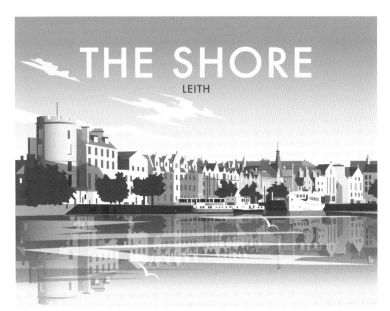

THE SHORE, LEITH, DAVE THOMPSON

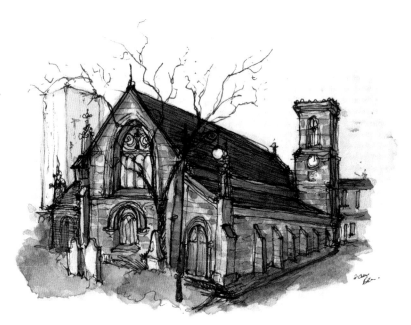

SOUTH LEITH PARISH CHURCH, SAM BLAIR

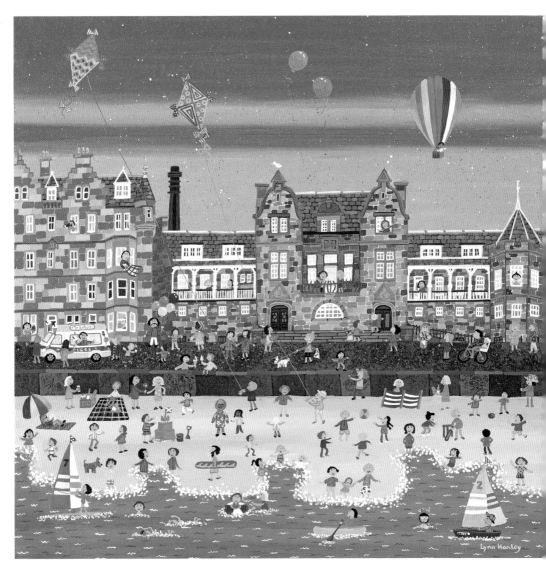

HAPPY DAYS AT PORTOBELLO, LYNN HANLEY

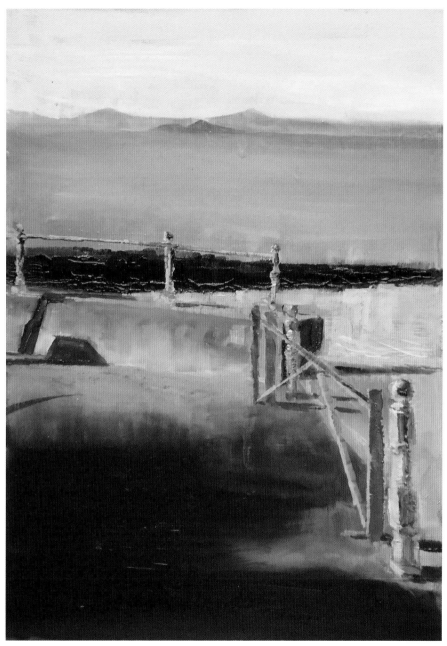

PORTOBELLO PROM, LINDSEY LAVENDER

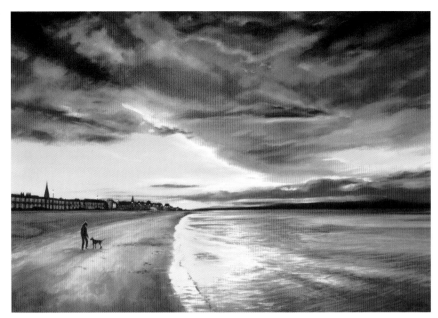

AND THE SKIES SANG, LYNN HOWARTH

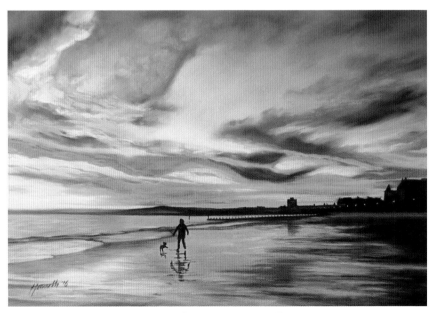

PORTOBELLO SUNRISE, LYNN HOWARTH

118

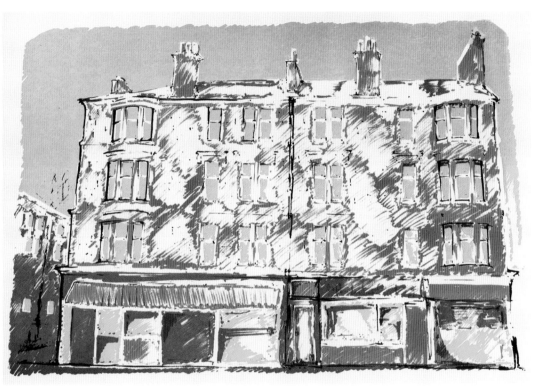

MORNINGSIDE TENEMENT, JOANNE FORBES

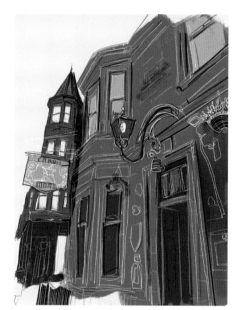

THE CANNY MAN'S PUB, LYDIA BOURHILL

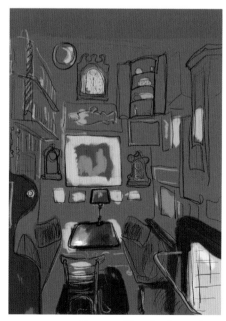

A COSY CORNER OF THE CANNY MAN'S PUB, LYDIA BOURHILL

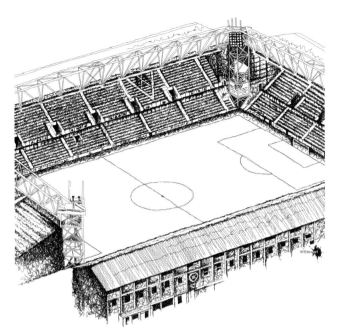

TYNECASTLE STADIUM, RACHEL STEWART

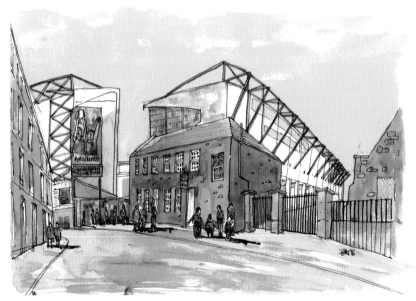

HIBS STADIUM, PAUL ISAACS

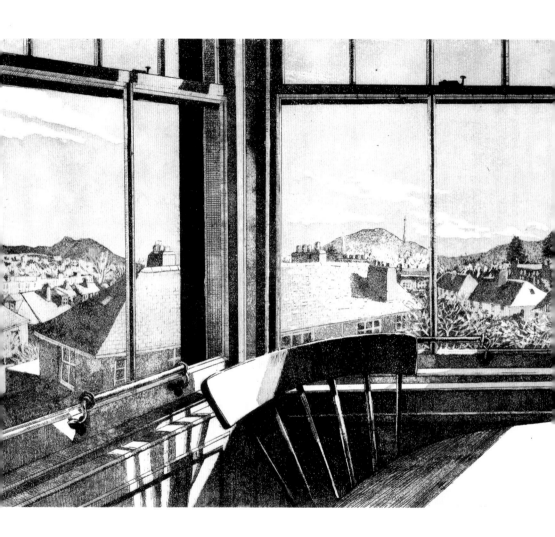

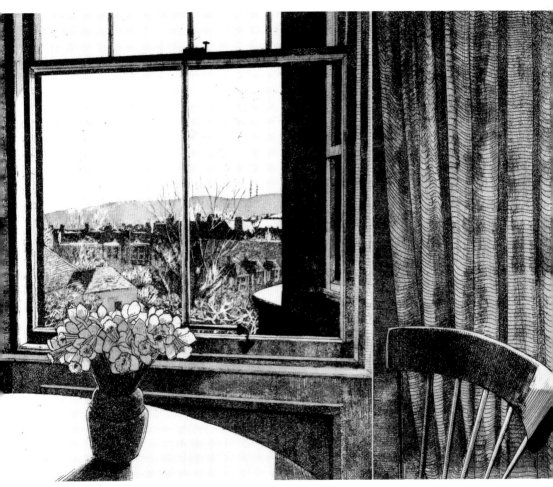

PLEWLANDS TERRACE, CAT OUTRAM

ARTISTS' CREDITS

Annie May Adam
Design and illustration combining
traditional printmaking and expressive
marks with digital collage
annie.may.adam@gmail.com
Pages 17, 66

Jane Askey
Landscape and still-life in a range
of media and techniques
www.janeaskey.com
Pages 13, 22, 71

Victoria Rose Ball
Detailed digital illustrations focusing
on architecture within Edinburgh and
hand lettered typography
www.victoriaroseball.com
Pages 55, 67, 81, 91

Alasdair Banks
International reputation for horse
racing paintings, his cityscapes reflect
the same spirited movement
www.alasdairbanks.com
Pages 13, 26, 80

Emma Bennett
Vibrant hand-cut collage using
recycled papers and hand-drawn
pictures
www.emmabennettcollage.co.uk
Page 30 and cover

Sam Blair
Maker of things. Illustrator at large
www.samblairillustrations.co.uk
Pages 36, 65, 115

Francis Boag
Joyous, expressionist interpretations
of the landscape of Scotland
www.francisboag.com
Page 22

Lydia Bourhill
Ink, watercolour and digital drawing
www.lydbourhill.wixsite.com/
bourhillustration
Pages 93, 104, 120

Richard Briggs
Pen and ink watercolour illustrations
of urban, coastal and rural landscapes
www.richardbriggs-illustration.co.uk
Pages 14–15, 38, 46, 98

Hugh Bryden
Printmaking artists books and
poetry pamphlets
www.hughbryden.com
Page 109

Laura Carolan
Mixed media drawing and illustration
exploring a sense of place
www.lauracarolan.co.uk
Pages 20, 106

Jonathan Chapman
Landscape and city illustrations
hand-painted with acrylic and ink
www.illustrationbyjonathan.com
Page 18–19

Liam Dobson
Oil on canvas, use of palette knife is a
vital of his artwork
www.Liamdobsonart.com
Pages 53, 102

Jenni Douglas
Hand pressed linocut
www.jennidouglas.co.uk
Pages 72, 83

Maria Doyle
Linocut prints, carved and
pulled by hand
www.instagram.com/maz.prints/
Pages 8–9, 41, 69

Yvette Earl
Hand-drawn and then digitally
coloured
www.yvette-earl.com
Page 37

Sally J Fisher
Collagraph prints hand-painted
with watercolour
www.sallyjfisher.com
Pages 28, 54

Joanne Forbes
Screen printing and drawings in a
range of media and subjects
joweegie@gmail.com
Pages 119

Alan Glasgow
Acrylic on canvas fine art paintings
alanglasgow5368@hotmail.co.uk
Pages 25, 107

Laura Gressani
Using printmaking to distill the
essential qualities of her subjects
www.lauragressani.com
Page 91

Rob Hain
A bird's-eye view of city life,
painted in acrylic on canvas
www.robhain.com
Pages 12, 21, 95, 97,114

Andrew Hamilton
Traditional fine ink drawings of
Scottish landmarks and architecture
www.ahamiltonsketches.com
Page 80–81

Lynn Hanley
Colourful, naïve style paintings
with quirky details and peppered
with tiny people
www.lynnhanley.com
Pages 23, 29,116

David Hardcastle
Continuous single line ink drawings
and places of cherished memories
chateau1000@gmail.com
Page 100–101

Cassandra Harrison
Maker of architectural artwork using
textiles, screen-printing, watercolour
and digital images
www.cassandraharrison.co.uk
Pages 82, 111

Sheenagh Harrison
Acrylic and mixed media cityscapes
and seascapes on canvas
www.sheenaghharrisonart.co.uk
Page 70

Claire Heminsley
The more you look the more you see!
www.incahoots.org.uk
Pages 27, 97

Rebecca Heselton
Artist, designer and illustrator
specialising in light pieces
www.rebeccaheselton.com
Page 103

Lynn Howarth
Pastel and acrylic paintings in a wide
range of subjects. Commissions
welcomed
www.lynnhowarth.co.uk
Page 118

Emily Ingrey-Counter
Drawings and paintings inspired by
the natural world
www.emilyingreycounter.com
Page 47

Paul Isaacs
Pen, ink and watercolour local
architectural studies
www.paulisaacs.co.uk
Pages 76, 121

Lucy Jones
Mixed media paintings and collage of
the Edinburgh Georgian architecture
www.lucyjonesart.com
Pages 90, 98

Hannah Kelly
Detailed pen and ink illustrations
of natural and urban landscapes
www.hannahkelly.co.uk
Page 74–75

Lindsey Lavender
Exploring rhythms of light and shade;
showing the everyday in a new light
www.lindseylavender.co.uk
Pages 60, 108, 117

Bob Lees
Former art teacher, creating
representational and semi-abstract
images. Acrylic and mixed-media
vallees@live.com
Pages 14, 57

Katrine Lyck
Danish illustration student at
Edinburgh College of Art focusing
on etchings
www.KatrineLyck.com
Page 106

Pam Mckenzie
Pam creates bright, vibrant expressive
paintings combining city views and
colourful wildflowers
Facebook: PamMckenzieArtist
Page 12

Hilke MacIntyre
Linocuts, woodcuts, ceramic
reliefs and paintings
www.macintyre-art.com
Page 48

Ross Macintyre
Watercolour and ink, paints
Edinburgh scenes, Scottish landscapes,
cityscapes, trees and flowers
www.rossmacintyre.com
Pages 15, 89, 94

Adrian B McMurchie
Known as The Glasgow
Illustrator, Adrian's architectural
watercolours have been a mainstay
in the Scottish commercial art scene
for over 20 years
www.amcmurchie.com
Pages 31, 34–35, 43, 61

Moy Mackay
Felted painting with dyed merino fibres and stitch
www.moymackaygallery.com
Pages 31, 42, 88

Sophie Martin
Artist and illustrator specialising in drawing from life in pen and watercolour
www.sophiemartinillustration.co.uk
Pages 40, 47, 48, 94

Ian Scott Massie
Portrays the personality of places through watercolour and screenprint
www.ianscottmassie.com
Pages 73, 96

Anna Middlemass
Digital paintings inspired by fairy-tales and wild places
www.annamiddlemass.com
Pages 77

Tomasz Mikutel
Watercolour artist born in Lodz (Poland), inspired by Joseph Zbukvic and Alvaro Castagnet
www.tomaszmikutel.com
Pages 64

Fiona Miller
Architectural illustrations in watercolour and ink-pen
www.fionamiller.net
Pages 33, 51

Kate Miller
Digital art and screen-prints
www.kate-miller.com
Pages 11, 23, 76, 104

Liana Moran
Large architectural drawings responding to the environment, structure and materials within cities
www.edinburghillustrations.com
Pages 44, 52, 105

Eilidh Muldoon
Hand-drawn linework and hand-printed textures arranged and coloured digitally
www.eilidhmuldoodles.com
Pages 59, 85, 112

Scott Naismith
Published Scottish semi-abstract painter. Scott uses expressive colour and exhibits worldwide
www.scottnaismith.com
Pages 100–101

Colm O'Brien
Colm O'Brien's articulate use of colour has attracted collectors world-wide
www.colmobrien.co.uk
Pages 24, 27, 32, 56, 102

Cat Outram
An etcher of cityscapes, landscape and all things that catch her eye
www.catoutramprintmaker.com
Pages 45, 122–123

Amanda Phillips
Amanda is a professional artist local to Edinburgh who exhibits all over Scotland
www.amandaphillips.co.uk
Pages 52

Clive Ramage
Atmospheric paintings and etchings of Scottish cities, land and seascapes
www.cliveramage.com
Pages 105

Lucy Roscoe
Illustration, artist's books and sculptural paper works. Illustrations commissioned for 'The Evergreen'
www.lucyroscoe.co.uk
Pages 67

Diana Savova
Realistic and fantasy paintings in different media including acrylic, watercolour and oil
www.artsavova.co.uk
Pages 58

Blythe Scott
Whimsical mixed media art, expressing an uplifting view of the world
www.blythescott.com
Pages 65, 84, 88, 89

Pamela Scott
Linocut prints
www.pamelascottprintmaker.com
Page 79

Sue Scullard
Black and white wood engravings
and pen drawings of landscape and
architecture
www.suescullard.co.uk
Pages 10, 78

Jenny Seddon
Handmade, limited-edition
screen-prints
www.jennyseddon.com
Map of Edinburgh

Esther Semmens
Detailed ink and watercolour
illustrations of architecture,
cityscapes and landscapes
www.estasketch.com
Pages 41, 84, 86–87, 99

Andrew Siddall
Architectural hand-drawn building
portraits and illustrations recording
city spaces and places
www.siddalldrawing.com
Page 62–63

Rachel Stewart
Rachel creates narrative
illustrations, digitally produced
in a scribble sketch style
www.rhstewart.com
Pages 44–45, 121

John Stoa
Dundee artist painting Scottish
landscapes, snow scenes, figures,
flowers and still life
www.johnstoa.com
Pages 20, 24, 49

Dave Thompson
Homage to iconic travel posters
rendered digitally in vector flat colour
www.davethompsonillustration.com
Pages 50, 115

Libby Walker
Libby's work celebrates the thriving
communities and sprawling
architecture of the city
www.libbywalker.co.uk
Pages 16, 68, 92, 110

Karen Warner
Energetic works created with oils,
pigment, beeswax, varnish and inks
www.karenwarner.co.uk
Pages 39, 113

Susie Wright
Screen-prints and drawings of
architecture, flora and fauna
www.susiewright.co.uk
Pages 32, 62–63

Every effort has been made to correctly credit contributors. In the case of any omissions or errors we would be pleased to make appropriate corrections in future editions.

ARTISTS

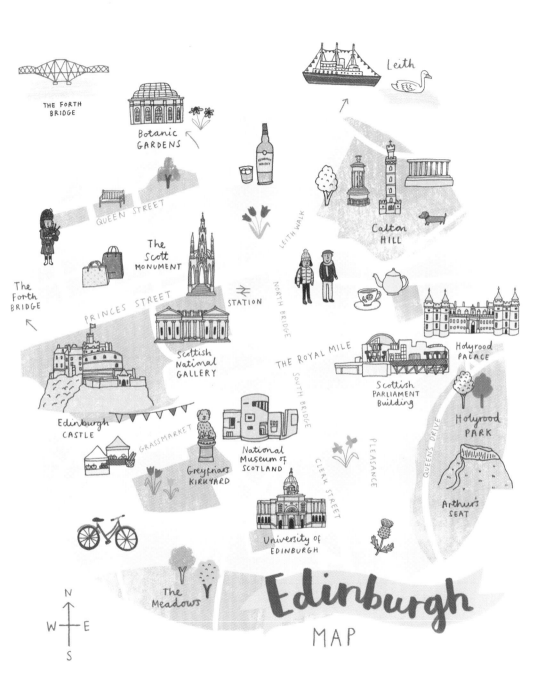